THE ONE–HOUR WATERCOLORIST

THE ONE-HOUR
WATERCOLORIST

Patrick Seslar

NORTH LIGHT BOOKS
CINCINNATI, OHIO
www.nlbooks.com

ACKNOWLEDGMENTS

My heartfelt thanks to all of the artists who so generously contributed their wonderful artwork to this book and took time from incredibly busy schedules to create, photograph and provide commentary for their demonstration paintings.

METRIC CONVERSION CHART		
to convert	to	multiply by
Inches	Centimeters	2.54
Centimeters	Inches	0.4
Feet	Centimeters	30.5
Centimeters	Feet	0.03
Yards	Meters	0.9
Meters	Yards	1.1
Sq. Inches	Sq. Centimeters	6.45
Sq. Centimeters	Sq. Inches	0.16
Sq. Feet	Sq. Meters	0.09
Sq. Meters	Sq. Feet	10.8
Sq. Yards	Sq. Meters	0.8
Sq. Meters	Sq. Yards	1.2
Pounds	Kilograms	0.45
Kilograms	Pounds	2.2
Ounces	Grams	28.4
Grams	Ounces	0.04

Other fine North Light Books are available from your local bookstore, art supply store or direct from the publisher.

05 04 03 02 01 5 4 3 2 1

Library of Congress Cataloging-in-Publication Data

Seslar, Patrick
 The one-hour watercolorist / Patrick Seslar.
 p. cm.
 Includes index.
 ISBN 1-58180-035-5 (pbk.)
 1. Watercolor Painting—Technique. I. Title.

ND2420 .S47 2001
751.42'2—dc21 00-042717

Edited by Nancy Pfister Lytle
Production edited by Nancy Pfister Lytle
Designed by Wendy Dunning
Interior production by Kathy Bergstrom
Production coordinated by Kristen Heller

Patrick Seslar

A graduate of Purdue University, Patrick Seslar has served as a contributing editor for *The Artist's Magazine* for over fifteen years, during which time he has written over one-hundred articles on art technique and art marketing. Seslar is the author of *Wildlife Painting Step by Step* (North Light Books, 1995) and *Watercolor Basics: Painting From Photographs* (North Light Books, 1999). He co-authored *Painting Nature's Peaceful Places* (North Light Books, 1993) with Robert Reynolds. Seslar's life and early paintings are profiled in *Becoming a Successful Artist* by Lewis Lehrman (North Light Books, 1992).

Seslar's monthly column of travel and humor was a regular feature in *Trailer Life* magazine for several years, and his writings have been published in numerous national magazines, including *The American West, Backpacker, Personal Computing* and *MotorHome*. He is listed in *Who's Who in U.S. Writers, Editors and Poets* (December Press, 1988), *Who's Who in America* (Marquis, 2000 edition) and in *Who's Who in the World* (Marquis, 2000 edition).

CONTENTS

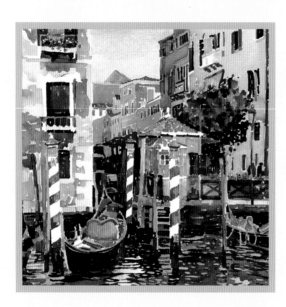

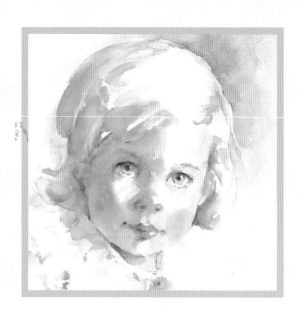

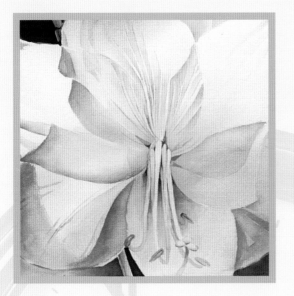

INTRODUCTION

*d*oes it seem like you can never find time to paint? Then, this book is for you! It is based on a simple premise: If you can set aside even one hour per week, you can complete a painting. In these pages, you'll see numerous examples of paintings that can be completed start to finish in one hour—including the time needed to prepare the paper and create the drawing. You'll also see examples of paintings that require some preparation beforehand (thirty minutes to one hour). For those subjects, you'll learn how to spend an hour or less developing the composition, drawing the image and masking where necessary so you'll be able to begin and complete the painting in a second one-hour session.

But, this book isn't just about quick one-hour paintings. It's also about giving you the confidence to attack larger and more complex images, knowing that you can break them down into a series of "bite-size" one-hour sessions. You'll see numerous examples of complex and sophisticated images and, in most instances, you'll be surprised by how few hours were really required to create them. Of course, each of the artists in this book is experienced so, depending on your skill and experience, it may take you a bit longer. But, the point of showing more complex multi-hour images is not to give you a blow-by-blow, hour-by-hour description of how to re-create them, but rather to show you what can be accomplished by putting a series of hours together. Once you realize that even complex subjects can be created by simply approaching them on an hour-by-hour basis, you'll realize that they, too, are within your reach, even when you have a limited amount of time to paint.

The artists' work shown on these pages represents a wide variety of subjects and styles, so no matter what you like to paint, or how, you're sure to find just what you're after. All you need to provide is a little willpower and the self-discipline to set aside the time for your own one-hour painting sessions. This book gives you an arsenal of timesaving tools and techniques that will help you make the most of the opportunity you've created.

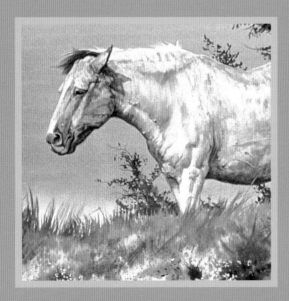

Getting Started

Procrastination is the enemy of accomplishment. Period. So, with that bit of "profundity" in mind, I've written this chapter to help you banish procrastination by following two time-tested adages: 1) plan your work, work your plan; and 2) KISS (Keep it simple).

In the first part of this chapter you'll discover how to plan your work by setting aside a time and place to paint and by setting realistic and achievable goals. In the second part, you'll learn how to keep it simple by choosing a basic selection of brushes and colors and by eliminating the tedium of stretching watercolor paper or by employing mechanical aids to speed the process.

OK, now let's get started and not waste another minute!

1

Make Time to Paint: Techniques to Save Time

Take One-Hour Vacations From Family, Friends and Phone Calls

Imagine for a moment that you are a major-league baseball player. It's the big game and you're at the plate. Just as the pitcher lets fly, you discover that the laces of your shoes are inextricably tangled together. Still, you somehow manage to hit a nice drive into center field. The crowd roars. Under normal circumstances, it might be a home run, but how hard do you think you'd run for first base knowing that you'd surely trip and be tagged out before you got ten feet from home plate?

What does baseball have to do with painting? Well, as odd as it may seem, finding an hour to paint each week is much like running for first base with tangled laces. The truth is that nearly everyone could find at least one hour per week to paint. The trouble is, most of us it find it easier to procrastinate. Figuratively speaking, we "tangle our laces" by thinking, What's the point? By the time I've cleared the space, got my "stuff" out and decided what to paint, most of the hour will be gone. In reality, for most of us the problem isn't lack of time; it is lack of faith that any meaningful painting can be accomplished in a one-hour period.

So, let's assume for a moment that maybe, just maybe, you really could accomplish something—that you could even complete an entire painting in one hour or less. If you were sure of that, wouldn't you be more motivated to watch one less hour of television, get up a little earlier, stay up a little later, find a sitter for the kids or ask someone to answer the phone for the next hour? Of course you would!

Okay, now let's tackle those nagging questions that have made it easier to procrastinate than to paint: Where will I work? Where did I put my painting stuff? And, what will I paint? In the sections that follow, you'll find answers that will have you painting within minutes and able to begin or complete a beautiful painting during each one-hour appointment.

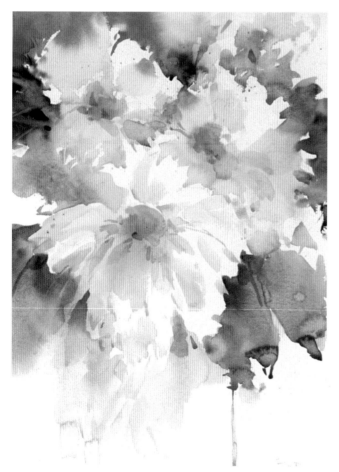

This delightful painting took Janet Rogers only forty-five minutes to complete. For further information on how you can follow her example, see her demonstration of *Cassandra* in chapter 3.

DAISIES
Janet Rogers
Watercolor on Arches 300-lb. (640gsm)
 cold-pressed watercolor paper
17" x 14" (43cm x 36cm)

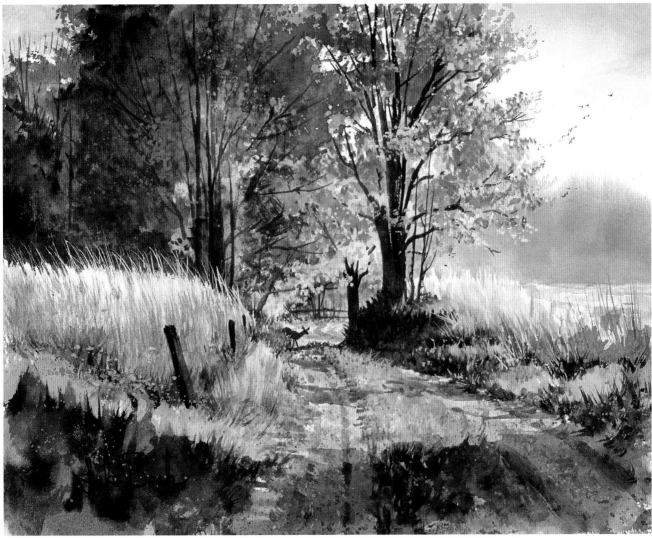

Luke Buck used a ¾-inch (19mm) aquarelle flat brush for about 75 percent of the work he did to complete this one-hour painting. The rest was painted with a ½-inch (13mm) aquarelle flat and a no. 3 rigger.

SHADY LANE
Luke Buck
Watercolor on Crescent
 cold-pressed watercolor board
8½" x 11" (22cm x 28cm)

Set Aside a Designated Work Area

Creating a designated work area assures you of a place to work consistently; it also provides a convenient place to store your stuff between sessions so you won't need to waste time looking for it or reorganizing it each time you sit down to paint. You'll have to exercise a little creativity to find a space to claim as your own, but, as the saying goes, where there is a will, there is a way.

Surprisingly, for most projects you don't need a huge studio with north light and all the trimmings. A tabletop in the kitchen, attic, laundry room, spare bedroom or basement will do just fine. A perfectly functional "studio" can be set up in almost any room using little more than a 2' by 4' (61cm x 122cm) folding table, an elbow lamp and a box of watercolors and brushes. If space is at a premium, the table and lamp can be folded and stored out of the way between sessions.

Painting in a Limited Space

If you think your space is limited, consider artist Robert O'Connor's (pictured) situation. He spends seven months each year traveling and painting in a travel trailer that measures only 8' wide by 30' long (2m x 9m). Even though this "home on the road" contains O'Connor's living room, kitchen, bedroom and bath, he still finds room for a portable studio setup and uses it to paint as many as sixty paintings during his travels.

A Compact Portable Painting Table/Easel

To solve his space problem, O'Connor designed his own portable painting table/easel. The tabletop consists of a 20" x 35" (51cm x 89cm) piece of ¾" (2cm) plywood covered with plastic laminate. It is supported by two interlocking pieces of ⅛" (0.3cm) tempered Masonite brand hardboard, each measuring 13" x 25" (33cm x 64cm).

The easel is designed to sit on top of a picnic table when O'Connor paints outside or atop a coffee table when he paints inside. The portable easel is supplemented with three small plastic stacking tables that serve as his taboret. On the topmost table he places his palette, water and brushes. The tabletop immediately below holds paper towels; the lowest tabletop stores odds and ends that are only occasionally needed. At day's end, the legs are removed from each table, the easel is taken apart and everything stows neatly behind the couch. If your space is limited, O'Connor's collapsible easel might be just what you need.

35" (89cm)

20" (51cm)

Formica top
¾" (2cm) plywood

⅛" (0.3cm) tempered masonite

13" (33cm)

25" (63cm)

Start Small—You'll Be Amazed at What You Can Accomplish in One Hour!

If your time and space are limited, working with smaller paintings has many benefits: Smaller images are easier to complete in the allotted time. What's more, each layer or wash takes only minutes to complete. Should you be interrupted, you won't find yourself in the middle of an unforgiving major wash. Smaller paintings also require fewer brushes and less work/storage space; a single sheet of watercolor paper goes a long way, as well!

Small paintings can be simple or complex. The choice is up to you. Here are a few examples that will give you a better idea of what is possible on a diminutive scale.

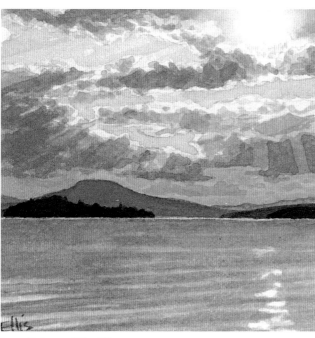

Leave Lights and Plan Values
"This painting works," says Pamela Jo Ellis, "because I spent a lot of time planning and carefully juxtaposing oranges and blues for the right effect while leaving the lights and carefully balancing values." Working small also helped make the painting take less time. *Lake Sunset* took Ellis just one hour to complete.

LAKE SUNSET
Pamela Jo Ellis
Watercolor on Arches 140-lb. (300gsm)
 cold-pressed watercolor paper
2½" x 2½" (6cm x 6cm)

"Small" Is a Relative Term
If you work quickly, as Harry Thompson does, an image as large as 14" x 10" (35cm x 25cm) can easily be classified as small. This painting took Thompson approximately one hour to complete.

ROLLINS COLLEGE
Harry Thompson
Watercolor on Strathmore bristol plate 3-ply paper
14" x 10" (35cm x 25cm)

Divide and Conquer: Strategies for Complex Subjects

*n*ot every painting can be completed start to finish in one hour. Sometimes, the process must be broken into smaller, more manageable one-hour sessions. When the subject is too complex to be completed in one hour, the first session (an hour or less) is usually devoted to preliminary sketching in pencil or color, preparing an initial drawing and stretching or otherwise preparing the paper. Subsequent one-hour sessions either complete the painting or advance it hour-by-hour toward completion.

Hour One: Develop an Idea and Preliminary Sketch

Many artists find it useful to spend their first hour developing an idea or two into usable compositions. Their inspiration usually comes from quick location sketches or, more frequently, from photographs or 35mm slides they've taken earlier. Once they've selected promising pieces of reference material, they create quick sketches in ink, pencil or watercolor to develop the raw ideas into compositions that can be painted in their next session in their entirety or that can be developed progressively in a series of hour-long sessions. Here are a few examples.

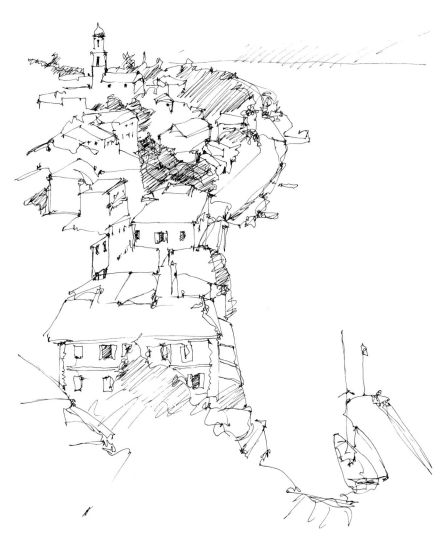

Presketch Unfamiliar Settings

Steve Rogers suggests an interesting use for sketching if you're going to travel to an unfamiliar setting to paint. Look for a video or printed reference of the area you'll be visiting and do a series of quick sketches like this to familiarize yourself with the unique forms you'll encounter. That way when you arrive, you'll already be "tuned up" to take full advantage of what you see. "I would never use a sketch like this as reference for a painting," says Rogers, "because they aren't from my own source material, but it is still a good exercise to stimulate my thinking prior to my trip."

UNTITLED INK SKETCH
Steve Rogers
24" x 18" (61cm x 46cm)

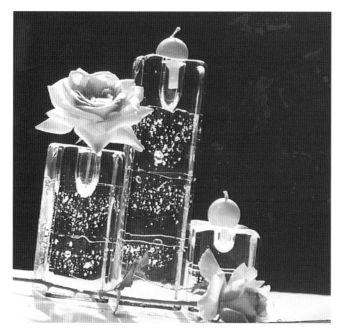

Find Great Subjects Close to Home

Although Susanna Spann travels widely, she often paints subjects closer to home. Using props from her own home and garden, she takes a series of photographs using different arrangements and different angles, then works out compositional sketches. You can save time as well by following her example: Choose subjects around or in your own home, then use a camera to quickly experiment with a variety of compositions before committing to paper and paint.

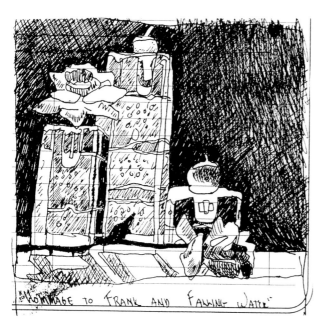

Sketches needn't be large or incredibly refined, nor does your sketchpad need to be fancy or expensive. Spann uses scrap typing paper and a medium-point felt-tip pen from a local office supply store to create many of her quick compositional sketches.

PRELIMINARY SKETCH FOR HOMAGE TO FRANK AND FALLING WATER
Susanna Spann
Ink sketch on typing paper
4" x 4" (10cm x 10cm)

UNTITLED INK SKETCH
Susanna Spann
Ink sketch on typing paper
5" x 4" (13cm x 10cm)

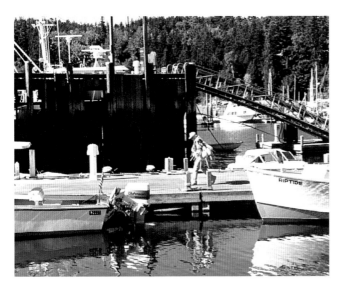

"Photo-Sketching" Saves Time

Robert O'Connor also travels extensively and often supplements traditional pencil sketches with reference photographs such as this. (I call this hybrid technique "photo-sketching.") When O'Connor returns to his studio, he uses his photographs as the basis for small color studies or to provide details that add life or interest to more complex paintings.

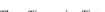

Photocopiers Speed Enlarging

After enlarging his photo-sketching on a photocopier, O'Connor drew this small sketch.

Three Timesaving Tips

Finally, O'Connor painted this small color study—and the whole process (enlarge, sketch and paint) took him less than an hour! You can work more quickly also by emulating O'Connor's three timesaving techniques: 1) Work from photographs when time is precious, 2) use a photocopier to quickly enlarge your reference to the desired scale and 3) keep the painting small.

FINISHED FOR THE DAY
Robert O'Connor
Watercolor on Arches 300-lb. (640gsm)
 cold-pressed watercolor paper
9" x 7" (23cm x 18cm)

Hour Two and Beyond: Begin (or Complete) a Painting

As much as you'd like to complete every painting in an hour or less, that isn't always possible (or desirable). Many worthwhile subjects simply cannot be completed in the space of an hour. But don't let the magnitude of the task deter you. It can be done—and more eas-ily than you think. The key to complet-ing multi-hour paintings is being able to "see the light at the end of the tun-nel." You can do that by breaking the painting process into manageable one-hour sessions so that each hour pro-duces definite progress toward your goal. As you gain confidence creating paintings in one-hour increments, you'll soon find that a five-hour or a fifty-hour painting doesn't seem so dis-tant and that even the most time-con-suming images can be conquered by dividing them into "bite-size" one-hour sessions. Here are some examples of multi-hour paintings to show you what is possible:

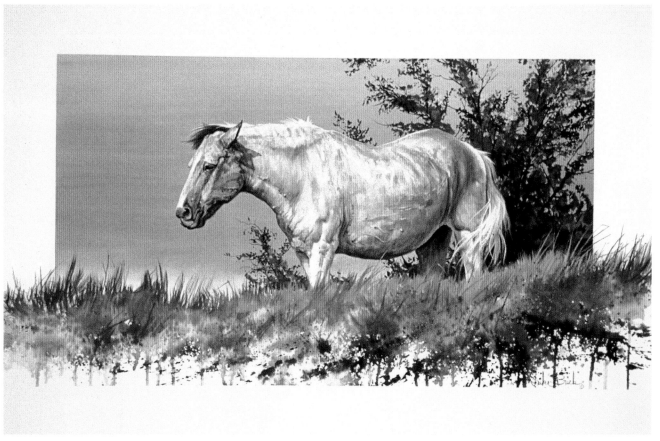

Divide and Conquer One Hour at a Time!
This highly developed painting took Luke Buck about sixteen hours to complete. Of course, Buck has been painting for many years so it may take you somewhat longer to create paintings of this complexity, but regardless of your level of experience, even paintings as sophisticated as this can be broken down into a series of progressive one-hour sessions.

OUT TO PASTURE
Luke Buck
Watercolor on Crescent
 cold-pressed watercolor board
20" x 30" (51cm x 76cm)

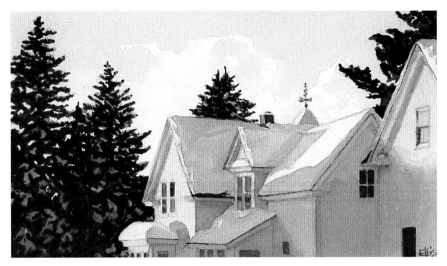

Organize Your Hours for Efficiency

This painting took Pamela Jo Ellis three hours to complete. In hour one she completed the drawing and applied first washes to the sky and pink areas on the buildings. In hour two she painted the shadows on buildings and trees and blocked in the dark tree forms. In hour three she "tweaked the three-dimensionality" of the buildings and adjusted the darks throughout the composition to assure a proper value range.

SUNSET GLOW

Pamela Jo Ellis
Watercolor on Arches 140-lb. (300gsm)
 cold-pressed watercolor paper
2½" x 4½" (6cm x 11cm)

Paint More Quickly Using a Limited Palette

David Maddern used a limited palette of Aureolin plus two pairs of complements (Cadmium Scarlet and Winsor Blue and Winsor Green and Alizarin Crimson) to move this painting along quickly while producing vibrant color interactions. This painting took Maddern two and one-half hours to complete.

DATURA

David Maddern
Watercolor on Arches 300-lb. (640gsm)
 cold-pressed watercolor paper
30" x 22" (76cm x 56cm)

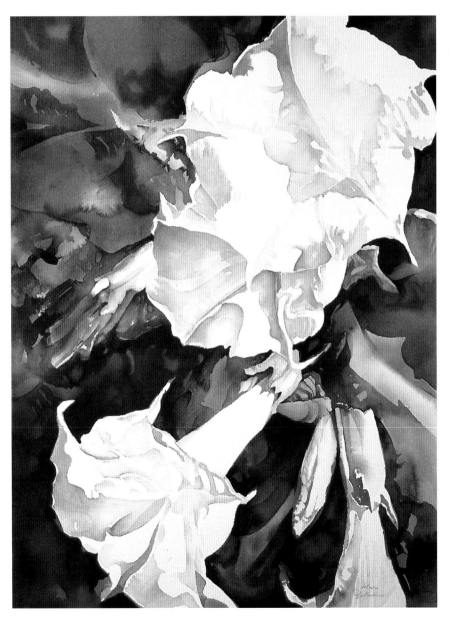

Use Layers of "Soup" to Create Color Harmony

Gustavo Castillo creates his paintings in layers using his palette colors in combination with a "soup" of colors that he premixes and applies as pale washes in the early hours of a painting. As additional layers of "soup" and palette colors are added during subsequent hours, the image grows more colorful and refined. Using the premixed "soup" saves time and helps assure harmonious colors. *Mangos* took Castillo twelve hours to complete.

MANGOS
Gustavo Castillo
Watercolor on Arches 300-lb. (640gsm)
 cold-pressed watercolor paper
30" x 22" (76cm x 56cm)

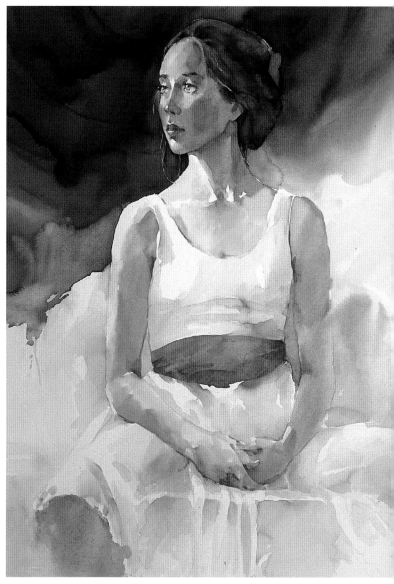

Warm Up With Quick Sketches

Janet Rogers uses a series of pencil and color sketches to warm up and become familiar with her subject before she begins a painting. With her sketches and color studies in hand for *Composition in Red & White—Ballerina*, she had an excellent grasp of the nuances of the subject. This allowed her to move quickly and complete the final painting in just eight hours.

COMPOSITION IN RED & WHITE—BALLERINA
Janet Rogers
Watercolor on Arches 300-lb. (640gsm)
 cold-pressed watercolor paper
32" x 25" (81cm x 64cm)

Watercolor Supplies

Tube Colors Versus Cake Colors

Whether or not to use tube colors or cake colors isn't really an either/or question. You may want both, but here are a few thoughts to consider.

Cake colors are compact and manageable, which makes them perfect for small studies painted on location. For major works, however, they simply cannot offer the range or selection of colors that is readily available in tube colors. Perhaps most important, because they must be scrubbed into a solution, cake colors are less suitable for creating "puddles" of color that are adequate for larger passages and they require considerably more effort and time when rich, heavily pigmented mixtures are needed.

Although a rose by any other name is still a rose, Cerulean Blue by different manufacturers is seldom the same. Despite similar color names, the exact hue, intensity and transparency or opacity varies among different brands of watercolors. One manufacturer's formulation may work well for one artist but be unsuitable for another. Because of this, many artists prefer to assemble a palette of colors from a variety of different manufacturers. But, regardless of who makes them, tube colors are generally preferable to cake colors because the moist pigments make it easier and quicker to create generous puddles of color for large washes as well as rich, intense colors when they are needed.

Choosing a Palette: How Many Colors Are Enough?

The options for filling your paint box and palette are both exciting and somewhat overwhelming. If you're new to watercolor, start with a basic palette of two colors, one warm and one cool, such as Ultramarine Blue and Burnt Sienna. You'll be surprised at the possibilities they afford. For more options, add a third color and work with a basic red, yellow and blue triad. When you've grown more familiar with mixing colors, you may want to add additional colors. As you read the step-by-step demonstrations in chapter 3, you'll discover that the artists who have contributed their work to this book assemble their palettes in many different ways. Use their examples as a guide when you're ready to expand your own palette.

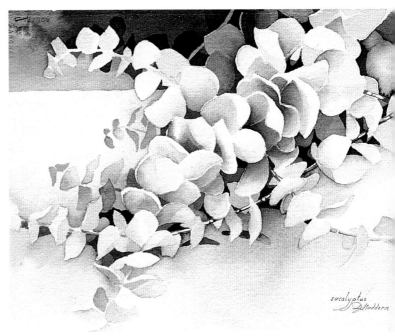

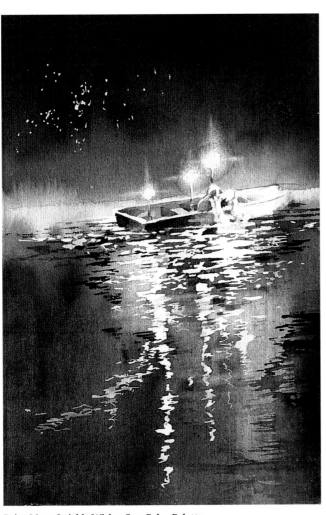

Paint More Quickly With a One-Color Palette
David Maddern completed this painting in only thirty minutes using a masking agent and only one color—Indigo! Painting with one color saves time and improves your ability to see and paint values effectively.

SHRIMPERS
David Maddern
Watercolor on Arches 300-lb. (640gsm)
 cold-pressed watercolor paper
15" x 11½" (38cm x 29cm)

Two-Color Palette
For Eucalyptus, David Maddern used only Winsor Blue and its complement, Cadmium Scarlet. Maddern selected these two colors because they mix to produce an extensive array of neutrals and semineutrals (warm and cool) as well as vibrant, deep browns and blacks. This painting took about forty-five minutes to complete. These two colors are hardly the limit of possible two-color palette combinations, so experiment freely and often. In most cases, you'll find that complementary colors produce the widest range of color variations.

EUCALYPTUS
David Maddern
Watercolor on Arches 300-lb. (640gsm)
 cold-pressed watercolor paper
11½" x 15" (29cm x 38cm)

Aureolin

Cadmium Scarlet

Winsor Blue

All three, wet in wet, to preserve some color identity

All three, wet in wet, to approach a colored Black

Try a Three-Color Palette
Here's a sample of the colors that can be produced with a three-color palette variation used by David Maddern. Colors are: Aureolin, Cadmium Scarlet and Winsor Blue. These are the three colors used in *Carnation*.

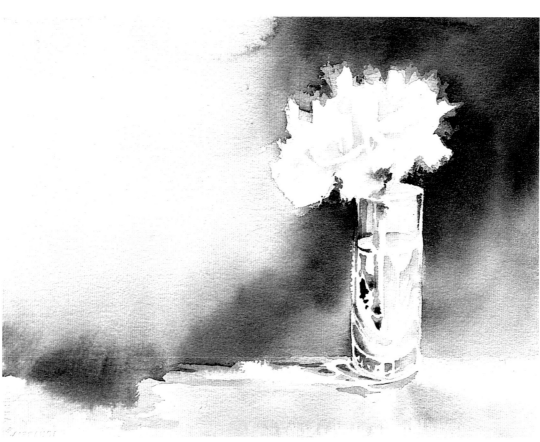

A Three-Color Painting
For this twenty-minute painting, David Maddern relied on only three colors: Winsor Blue and its complement, Cadmium Scarlet, plus a tiny bit of Aureolin to augment the basic color mixtures available from the two complementary colors. With fewer colors to consider, color harmony is almost assured and mixing goes much more quickly.

CARNATION
David Maddern
Watercolor on Arches 300-lb. (640gsm)
 cold-pressed watercolor paper
11½" x 15" (29cm x 38cm)

How Many Brushes Do You Really Need?

Your choice of brushes depends largely on your painting style and the size of paintings you wish to create. If your paintings are more impressionistic and generally larger, like those of Steve Rogers or Tracy Reid, you may need only a few larger brushes. If your paintings are more detailed, like those of Susanna Spann or Robert O'Connor, you may need a larger selection of brushes. As a general rule, however, it's best to use the smallest number of brushes and get to know their working characteristics well. Experiment to see how much color each brush holds and for how long. How well does it hold a point? Avoid bargain brushes. Quality brushes nearly always work better. Synthetic sables are an excellent, cost-effective choice for most routine uses. Finally, don't assume that all brushes are created equal. Surprisingly, even when two brushes share common specifications (e.g., no. 4 rounds made of synthetic sable), many small variations in construction affect their performance, so try different brands to find one that works best for you. In the meantime, here's a basic selection of five brushes that works well in most situations.

No. 1 Flat Brush

Any good synthetic sable or red sable brush performs nicely for pre-wetting paper, as well as for wet-in-wet effects (soft backgrounds) and smooth graded washes (in skies, for example). To save time, buy two. Keep one clean for pre-wetting and use the other to apply washes of color. (See illustrations of sample strokes.)

Typical brushwork produced using a no. 1 flat brush

No. 8 Round Brush

This is a very versatile brush. It carries lots of paint and forms a good point. It's great for laying down heavier lines, such as twigs and branches, and for creating graded tones in smaller areas, such as flower petals or leaves. By squeezing the hairs between a thumb and forefinger to splay the brush, it can be used on edge for fine lines or broadside to create useful dry-brush textures.

Brushwork produced using a no. 8 round brush

No. 4 Round Brush

This is the little brother of the no. 8 round. It does the same kinds of things on a smaller scale. It's great for smaller twigs, branches and some grasses, as well.

Brushwork produced using a no. 4 round brush

No. 1 Liner Brush

With hairs twice as long as on a standard brush, a liner forms a precise point and is a master at producing fine lines for twigs, grasses, ship's rigging and such. Buy sable or red sable because it holds a better point than the synthetic variety.

Brushwork produced using a no. 1 liner brush

No. 1 Bristle Fan Brush

This brush produces many useful and interesting textural effects, particularly for quick dry-brush passages when painting grasses or foliage. The bristles of these brushes vary considerably in stiffness and length, so you may need to experiment with a few to find one that's right for you.

Brushwork produced using a no. 1 bristle fan brush

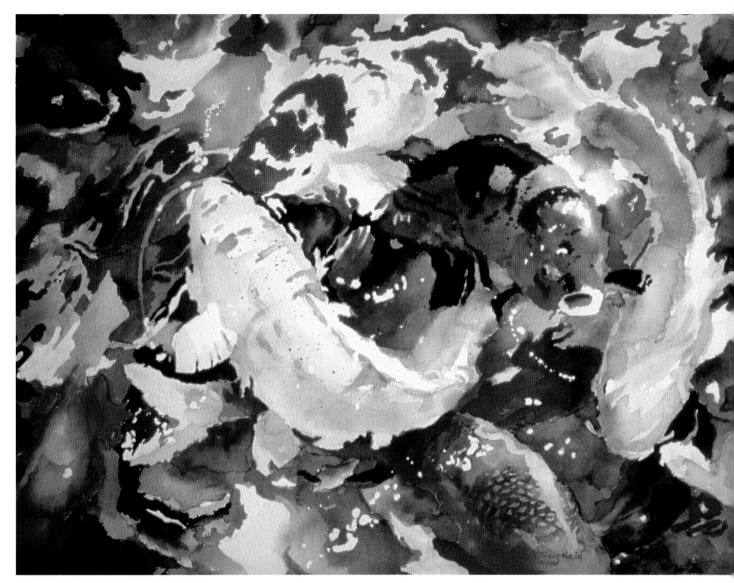

Although Tracy Reid estimates that it took between eight and twelve hours to complete this painting, she used only three large round brushes, nos. 8, 10 and 14.

UP FROM THE DEPTHS
Tracy Reid
Watercolor on Arches 300-lb. (640gsm)
 cold-pressed watercolor paper
22" x 30" (56cm x 76cm)

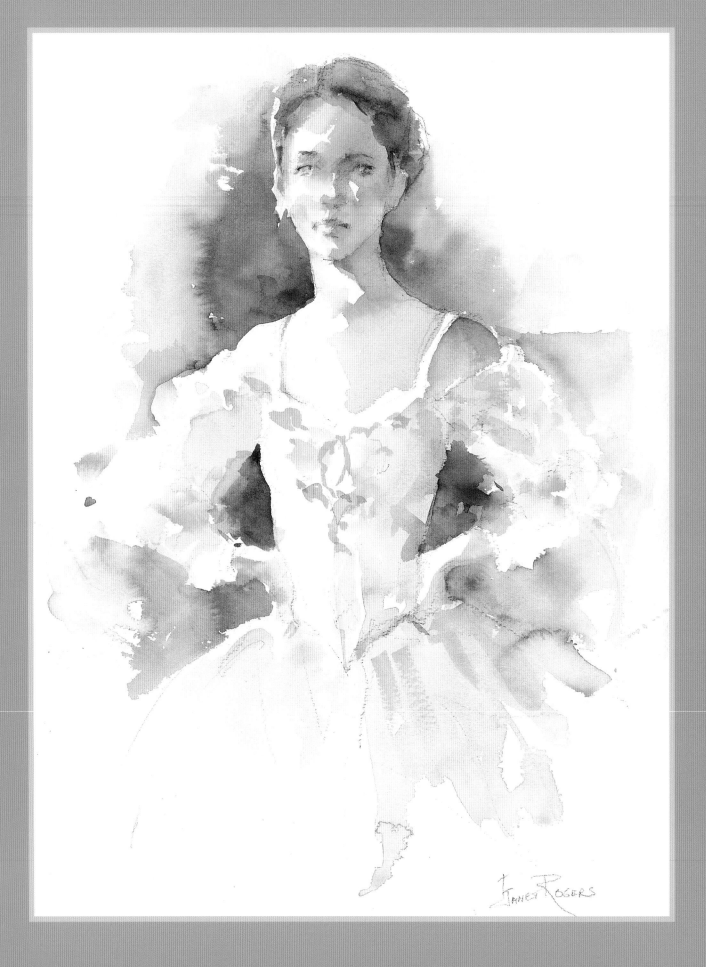

Janey Rogers

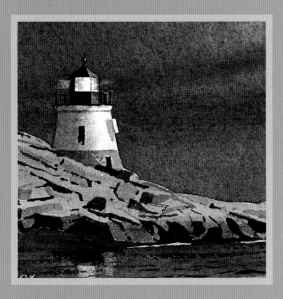

TIMESAVING TECHNIQUES

In this chapter, you'll attack indecision. You'll learn how to collect reference material that fills your head with ideas you can barely wait to paint; you'll learn to think more creatively and assess compositions more critically. You'll also learn to focus your ideas more clearly and get them on paper rapidly. And finally, you'll discover that, even with a limited amount of time, complex textures and images can be created by using a succession of quick and easy painting techniques.

Also in this chapter, you'll learn four key techniques that will streamline the painting process and make it easier to accomplish more in each hour-long session. In part 1, you'll see how to build and use an idea file to stimulate your creative juices and keep them flowing. In part 2, you'll discover techniques for turning rough ideas into workable compositions. In part 3, you'll explore several mechanical aids that will help you quickly translate your compositions into full-size drawings. And, in part 4, you'll get an overview of essential painting techniques that will help you get the most out of each minute of every painting session.

2

Stubborn As a Muse: Giving Yourself a Creative Kick in the Pants

Creating a painting in one hour (or even over several hour-long sessions) is as much about motivation as it is about mastering speedy techniques. One of the best ways to get motivated and stay that way is to assemble an idea file of your own sketches and photographs. So, in the next few pages, you'll find a number of suggestions about what to include as well as how to get more mileage out of what you have collected. You'll also find some sage advice on the pluses and minuses of composition. And finally, because paintings and photographs created by others are such a useful source of ideas, you'll find several resources that provide more specific details on intellectual property law and how it may affect you. Let's start by looking at what to include in your own idea files.

Build an Idea File

Just as a building is built one brick or one girder at a time, so it is with idea files. If you enjoy sketching, develop the habit of carrying a compact sketch pad or a small traveling watercolor sketch box. Before long you'll have an extensive stockpile of ideas that can be developed into one-hour or multiple-hour paintings. If you're short on time (aren't we all?), always keep a camera handy. It's the best solution for capturing a fleeting sunset, a porch bedecked in flowers or whatever strikes your fancy. (For more examples of photographic idea files, see "Work From Your Favorite Photographs" later in this chapter.)

A 35mm SLR (single-lens reflex) camera is the best overall choice for collecting photographic references because it offers a variety of interchangeable lenses from wide angle to zoom. Perhaps more important, with this type of camera what you see through the viewfinder is exactly what you'll get on film.

If you're cameraphobic or don't have much to spend on camera equipment, many so-called disposable or single-use cameras are available for under ten dollars and will do the job nicely.

Traditional photographic prints are convenient but quickly become cumbersome when your idea files grow large. A better choice all-around are 35mm slides because they take up far less space and provide truer and more lifelike color. A photographer's loupe and light table make it easy to view, compare and sort large numbers of slides at once.

When it comes time to paint, many artists shy away from 35mm slides, despite their obvious benefits. Artists fear they'll need darkened rooms and noisy projectors. A battery-operated, handheld viewer such as this is inexpensive, and when held to the eye like a telescope, it produces a visual sensation that is surprisingly like revisiting the scene in person.

A camera is ideal for capturing fleeting moments, such as a sunset or a person or animal in motion.

Learn to Play "What If?"

Playing "What if?" is simply artistic brainstorming. For example, what if I painted a subject more abstractly? What if I used a limited palette or painted it at a different time of day or in a different season? What if I included other elements that weren't originally present or removed items that weren't essential?

Another way to stimulate your creativity is by studying compositions and techniques used by other artists and then asking, "What if?" For example, what if you emulated the colors used in another artist's painting even though your subjects or styles had little else in common? What if you adapted another artist's landscape composition for your next still life or vice versa? Impossible? Try it!

Learn to look beyond the obvious interpretation of your subject by asking, "What if?" and you'll expand your artistic horizons many times over.

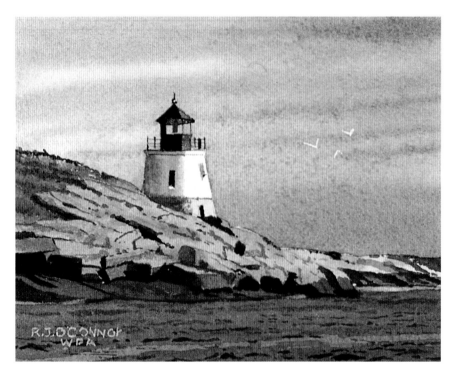

Although Robert O'Connor saw this lighthouse on a sunlit afternoon, he painted this version by asking, "What if it had been near twilight on a slightly overcast day?" This painting took forty-five minutes to complete.

CASTLE POINT LIGHT #1
Robert O'Connor
Watercolor on Arches 300-lb. (640gsm)
 cold-pressed watercolor paper
4" x 5" (10cm x 13cm)

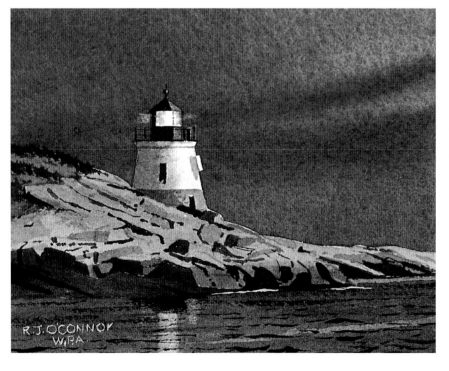

Once again asking "What if?" Robert O'Connor painted this version to explore how the lighthouse might appear at night with its beacon fully illuminated against the night sky. This painting took forty-five minutes to complete.

CASTLE POINT LIGHT #2
Robert O'Connor
Watercolor on Arches 300-lb. (640gsm)
 cold-pressed watercolor paper
4" x 5" (10cm x 13cm)

Make It Your Own: The Legality of Using Others' Photographs and Artwork

*n*o doubt shortly after the first caveman discovered art by drawing a wild beast on a cavern wall, another similarly inclined caveman, inspired by his example, quickly sketched a beast of his own. We'll never know if they felt proprietary rights in their creations, but with the evolution of mankind and the modern legal system, we now have an extensive body of law pertaining to intellectual property rights (e.g., copyright and trademarks).

In general, these are the rights owned by the creators of commercial products, such as soft drinks or toys, photographs (including movies and videos), sketches, drawings and paintings. In addition, many laws also cover the right to personal privacy. Suffice it to say that infringing on the intellectual property rights or privacy rights of others can have unpleasant legal consequences. Although the complexities and subtleties of intellectual property and

personal privacy law are well beyond the scope of this book, all artists should at least keep abreast of the major issues and areas of concern. For more specific information, consult the *Legal Guide for the Visual Artist* (4th edition) by Tad Crawford (Allworth Press, 1999) or research back issues of *The Artist's Magazine* for Joshua Kaufman's "In Your Corner" column.

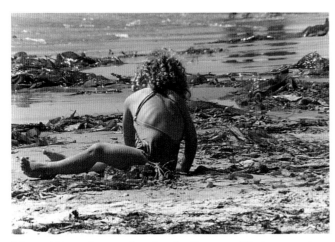

Privacy rights apply to people and, unless they are public figures, under most circumstances they own the rights to their own likenesses. Fortunately, most people are happy to be immortalized in a painting. Even so, although scenes such as this beg to be painted, if the child in question isn't your own, be sure to ask the parent's permission or obtain a model release (available as preprinted forms from many photographic supply houses).

If you enjoy painting people, try carrying preprinted model releases in your sketch kit. A simpler solution is to recruit models from family, friends or relatives. Pamela Jo Ellis's model for Treasure Hunting was her son, Connor. This painting took five hours to complete.

TREASURE HUNTING
Pamela Jo Ellis
Watercolor on Arches 140-lb. (300gsm)
 cold-pressed watercolor paper
5" x 5" (13cm x 13cm)

Create Great Compositions Quickly

*t*raditionally, artists have relied on hand-drawn sketches to develop compositional ideas. But, technology marches on and the advent of photography has changed the way many artists work. Instead of sitting in a field sketching for hours at a time, many contemporary artists snap quick photographs of desirable subjects so they can work them out later in the comfort of their studios. And now, even photography is giving way to a newer medium—the computer and digital imaging. In the next few pages, I'll cover each of these topics and give you some useful suggestions that will help you make the most of your reference regardless of which approach to composition you decide to use.

Practice Rapid Sketching

When you're trying to accomplish a lot in a short time—an hour, for example—rapid is the key word. If you don't need to spend hours developing your sketches, then don't. Use them to quickly record only the essential information you need about your subject so you can move on to the painting phase as swiftly as possible. Here are a few examples of rapid sketches created by several of the artists whose work you've seen throughout this book. Most of these sketches took only a few minutes to complete.

This is an actual page, 11" × 8½" (28cm × 22cm), from Gustavo Castillo's sketchbook, and it's the epitome of what rapid sketching is all about. With no wasted time or effort, Castillo divided the page into four sections and used a fine-point felt-tip pen to quickly sketch the rough shapes and shading of each of the elements in his still-life setup from several angles. (You can see more sketches from this session in Castillo's demonstration in chapter 3.)

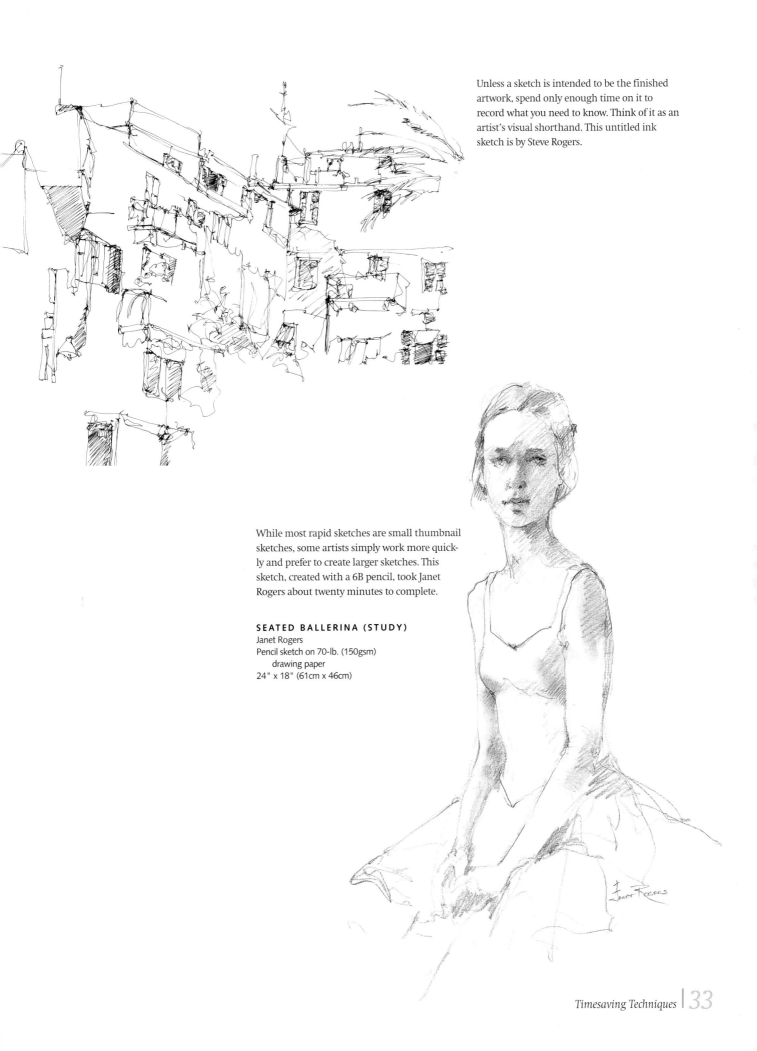

Unless a sketch is intended to be the finished artwork, spend only enough time on it to record what you need to know. Think of it as an artist's visual shorthand. This untitled ink sketch is by Steve Rogers.

While most rapid sketches are small thumbnail sketches, some artists simply work more quickly and prefer to create larger sketches. This sketch, created with a 6B pencil, took Janet Rogers about twenty minutes to complete.

SEATED BALLERINA (STUDY)
Janet Rogers
Pencil sketch on 70-lb. (150gsm)
 drawing paper
24" x 18" (61cm x 46cm)

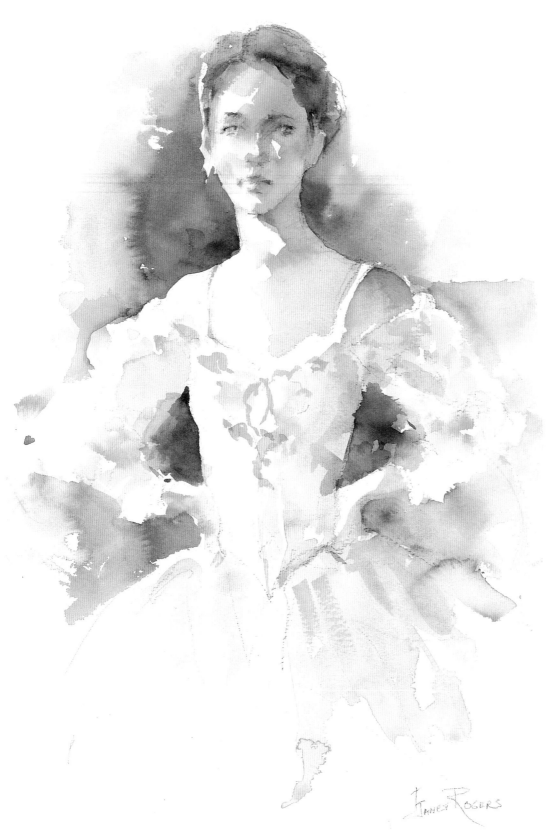

Because Rogers paints quickly, she is able to complete rapid sketches in color like this, usually in thirty to forty minutes.

BALLERINA IN WHITE
Janet Rogers
Watercolor on Arches 140-lb. (300gsm)
 rough paper
20" x 14" (51cm x 36cm)

Work From Your Favorite Photographs

Many artists now use a camera to capture raw material in the field and then later either sketch directly from prints or slides or enlarge from them using one of the methods described later in this chapter. Unfortunately, a camera doesn't do much to develop drawing skills. It does, however, help immensely in developing a sense of composition, because every time you frame a potential subject in your viewfinder, you assert and further develop your own aesthetic sense.

The degree to which you find it necessary or desirable to interpret your photographic reference is mostly a matter of personal preference. For more detailed instructions on how to paint from photographs, you may want to locate a copy of *Watercolor Basics: Painting From Photographs* (North Light Books, 1999). In the meantime, the examples that follow illustrate ways that photographic source material can be modified to create paintings that are new, different and, hopefully, better than the photographs that inspired them. So, let's have a look!

Here's a typical example from my photo-reference idea file. Not much to look at as is, but in another situation, it offered considerable potential.

Perhaps because it was near Halloween, it seemed I was surrounded by pumpkins. I took many photographs thinking that one day they might come in handy in case pumpkins were out of season at the local market when I needed to know what one looked like.

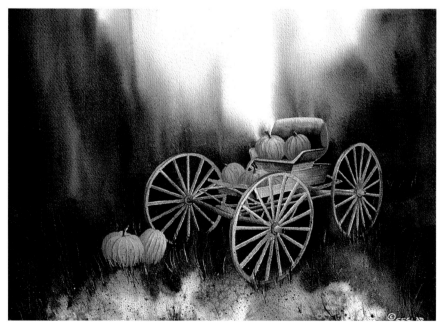

Of course, "one day" came sooner than I'd expected. Back in my studio, I drew the wagon and then referred to my pumpkin photographs to get their shapes and colors right before completing Pumpkin Wagon #2 in about four hours.

PUMPKIN WAGON #2
Patrick Seslar
Watercolor on Arches 300-lb. (640gsm)
 cold-pressed watercolor paper
12" x 16" (30cm x 41cm)

Mat Corners Zoom to the Heart of Your Subject

Cropping is a key technique in the search for good composition. Basically, it means that with whatever tools you have at hand, you cover selected portions of your photographic reference to test various formats (e.g., square versus long and skinny) or to eliminate unwanted or uninteresting portions of the reference. Your cropping tools can be as simple as a roll of masking tape or a few strips of mat board or index cards, or you can use one of several commercially available aids.

Photo by Robert O'Connor

Zoomfinder

The Zoomfinder can be found in many art supply stores. It provides a simple way to zoom in on portions of a photographic print or slide while obscuring unwanted areas from view. You can create a similar effect using two L–shaped pieces cut from scrap mat board or even by overlapping 3" x 5" (8cm x 13cm) unlined index cards over a photographic print.

I often use the cardboard mounts of other slides to temporarily cover unwanted portions of an image as I work out a useful composition. For a more permanent mask, try this silver slide masking tape available from Light Impressions (800-828-6216) or order it from their web site at www.lightimpressionsdirect.com.

Crop, Color and Print Your Composition with a Home Computer

The arrival of digital image-editing software for home computers has given artists many powerful new tools for exploring compositional ideas at a much faster rate than ever before. At present, image-editing software is still a "middle-man" between photographic reference and the paintings that are developed from them. In the next couple of years, however, as computers, software and artists become more sophisticated, we may see more paintings created entirely in the digital world without need of paint or brushes. Whew! Imagine that!

With image-editing software, it's easy to select a portion of an image to see if it works well on a full sheet of watercolor paper or whether it would be more striking as a vertical or horizontal format. As you'll see in the following examples, image-editing software makes it incredibly easy to play "What if?" by excerpting desirable elements from one image and transplanting them into another. In this way, the whole usually becomes greater than the sum of the parts. Of course, you'll still have to apply your own painting skills and artistic sensibilities to translate photo-composite references into beautiful paintings. Shall we go digital?

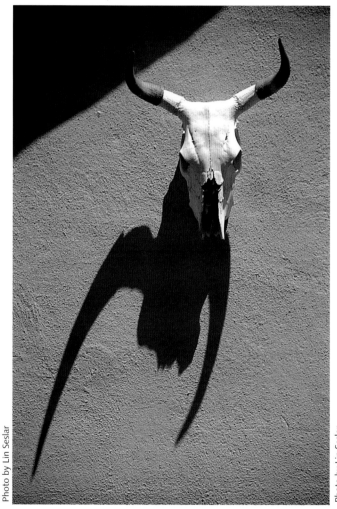

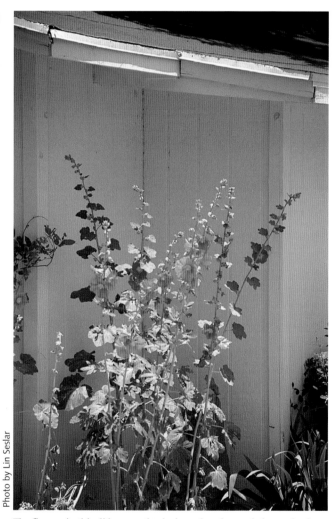

This slide is from my wife, Lin's, photo-reference files. It had great potential but seemed to lack some essential element. Nevertheless, I scanned it into my image-editing program (Adobe Photoshop) using a Microtek 35 Plus slide scanner. This took about thirty seconds.

The flowers in this slide seemed to be just what she needed to make the Santa Fe cow skull into a workable composition, so I scanned it into my image-editing software as well. Then I used the software to mask out everything except the flowers, leaves and stalks. The result was a selection that I could transplant into another image as well as resize, recolor or modify in any of a hundred other ways. This took about twenty minutes.

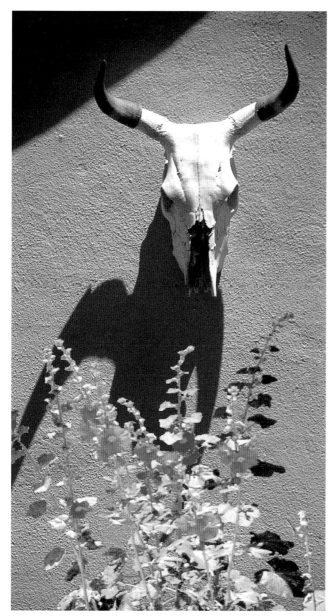

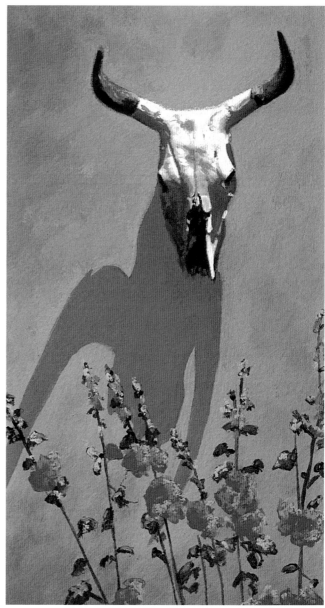

When the two previous images were composited, this was the result. Clearly, the dark shadow in the upper left corner had to go and all the shadows needed to be lightened and made more colorful, but even so, Lin had a good idea of how the final painting might look before she had ever lifted a brush.

After printing the composite image out on an Epson 720/1440-dpi color ink-jet printer for reference, Lin created the finished painting in about an hour. After masking out the skull with liquid masking fluid, she painted the background using transparent watercolors. With the masking removed, she painted the skull, then completed the blossoms and some leaf details using gouache (opaque watercolor).

SANTA FE
Lin Seslar
Watercolor on Arches 300-lb. (640gsm)
 cold-pressed watercolor paper
7¼" x 5" (18cm x 13cm)

Enlarge Sketches, Drawings and Reference Photographs in Minutes

*t*he ability to draw freehand is cherished by most artists, but let's face it, we don't always have enough time to take the leisurely route and some of us are simply not as gifted in this area as others. Here are a few mechanical aids that will have you creating preliminary drawings for your paintings in minutes! In time, you'll find yourself almost involuntarily making freehand corrections and adjustments to them, but for now let's see how to get a basic drawing down quickly.

Photocopiers

For simple enlargements or reductions from photographic prints or hand-drawn sketches, go to nearly any office supply or copy center and experiment with a black-and-white or color copier. The cost is nominal, and most machines allow you to set the degree of enlargement or reduction as a percent, e.g., 50 percent, 100 percent or anything in between. Many copy centers now offer a similar service for 35mm slides as well as computer digital-imaging workstations that greatly expand the possibilities for working with your reference slides, photographs or drawings (as described in "Crop, Color and Print Your Composition With a Home Computer" in the previous section).

Grids

One of the simplest low-tech solutions for enlarging your reference is the "grid" method. It's a bit tedious at times, but as you re-create the lines within each grid box, you'll begin to develop a keener eye for shapes and contours. You can use more than one grid, if need be, to enlarge and transfer elements from different reference sources onto the same drawing. The following steps show you how it's done.

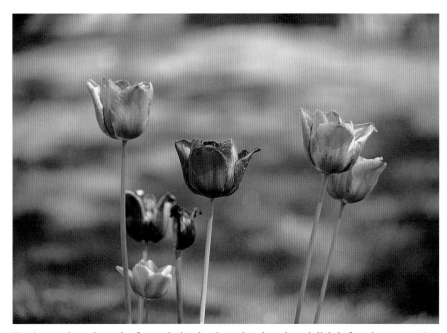

Here's a good starting point for a painting, but it needs to be enlarged slightly from its present 6" x 4" (15cm x 10cm) size to fit on a 10" x 7" (25cm x 18cm) piece of Arches 140-lb. (300gsm) cold-pressed watercolor paper.

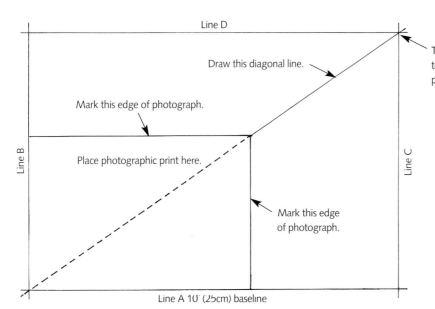

Line D

Draw this diagonal line.

This point marks height proportionate to baseline A for same proportion as photograph.

Mark this edge of photograph.

Line B

Place photographic print here.

Line C

Mark this edge of photograph.

Line A 10" (25cm) baseline

one A 6" x 4" (15cm x 10cm) photographic print scales up almost (but not quite) to a 10" x 7" (25cm x 18cm) watercolor block. Still, I wanted to keep the same proportion in the finished painting as the reference photograph and use the watercolor block. So, just to make sure everything fit, I grabbed a slightly larger piece of tracing paper and drew a 10" (25cm) baseline (A), then two vertical lines (B and C) at either end to represent the sides of the enlarged image. Next, I placed the photograph on its side in the lower left corner of the U shape I'd drawn and marked the top and right sides of the photograph in pencil. I then removed the photograph and used a ruler to mark a line diagonally upward until it intersected the vertical line on the right. To complete the box, I used a drafting T-square to draw a second horizontal line (D) across the top at the point where the diagonal line intersected the vertical line (right). The box measured 10" (25cm) tall and just over 6⅝" (17cm) wide.

two To enlarge from the photograph, I laid a piece of clear acetate over it and, with a fine-point permanent marker, drew lines around the outer edges, then divided the "box" in half vertically and horizontally. To make enlarging easier, I again halved each of the boxes I'd just created, with two more vertical and two more horizontal lines. For very complex subjects or for complex areas within a subject, you may want to subdivide some or all of the "boxes" another time to provide for more precise placement of details.

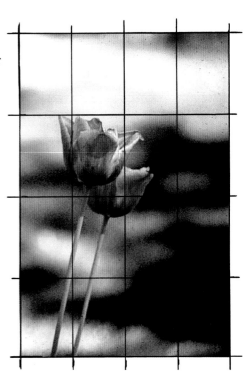

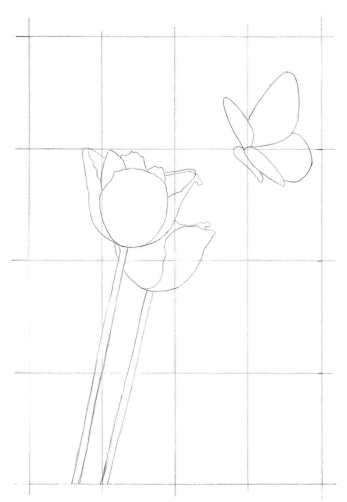

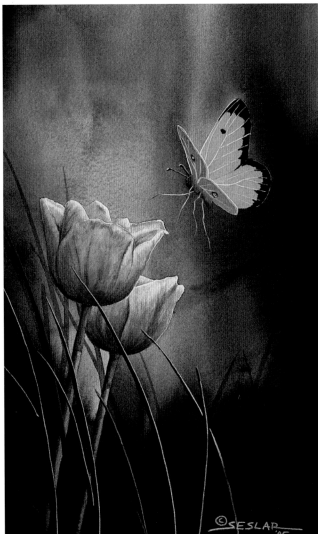

three Next, I drew lines to divide and subdivide the box I'd drawn on the tracing paper earlier until it had the same number of blocks, though they were larger, as the acetate overlay on the photograph. Then, with the grid on the photograph as a guide, I used a no. 2 office pencil to draw shapes on the tracing paper corresponding to each grid on the photograph. Finally, for interest, I positioned a tracing of a butterfly I'd drawn earlier beneath the tracing of the flowers and drew its outline, as well.

When I placed the tracing over a 10" x 7" (25cm x 18cm) block of Arches 140-lb. (300gsm) cold-pressed paper, I decided the composition would be stronger if I moved the entire image down the sheet slightly. Doing so eliminated part of the uninteresting stems and provided more airspace above the flowers and butterfly. When I was satisfied, I redrew each of the lines on the back of the tracing with the office pencil to cover them with graphite. Finally, I turned the tracing face up once again and went over each of the lines with the pencil to transfer them to the top sheet of the watercolor paper block.

four Here's the result. I masked the flowers, stems and butterfly with liquid masking fluid, then painted the background with a 1-inch (25mm) flat brush wet-in-wet with various mixtures of Sap Green, Warm Sepia, Charcoal and Yellow Ochre. When that dried, I removed the masking and painted the stems with the same colors and a no. 4 round brush. Finally, I painted the blossoms with the same brush and mixtures of Alizarin Crimson and French Ultramarine Blue. For the butterfly, I used Charcoal and Cadmium Yellow Medium. I painted the antennae, legs and the veins on the wings with a no. 1 liner brush. This painting took about two hours to complete.

TULIPS
Patrick Seslar
Watercolor on Arches 140-lb. (300gsm)
 cold-pressed watercolor block
10" x 7" (25cm x 18cm)

Pantographs

Pantographs are a slightly higher tech solution for enlarging. They're a rather ungainly looking assembly of bars and pins that attaches to the edge of a table. By moving pins at the pivot points of the interlocking *X*s, you can alter the degree of reduction or enlargement the pantograph will produce by tracing key elements on your reference. Pantographs can be a bit awkward, but they're inexpensive (usually under thirty dollars) and effective. You can find one at your local art supply store. Here's a simple example of an enlargement made with a pantograph.

Here's one of several shots I took when the magnolias were in bloom. It will make an interesting painting, but the present orientation is boring.

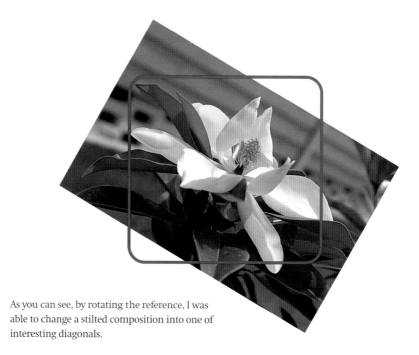

As you can see, by rotating the reference, I was able to change a stilted composition into one of interesting diagonals.

Using the pantograph's nylon tracing point, I followed the contours of each leaf and petal on the photograph with the enlargement ratio set at two. This created a rough outline on tracing paper that I smoothed up afterward with a drafting French curve template. I left some leaves out during the pantograph session and slightly altered the shapes of several other leaves and petals before tracing the enlarged and rotated drawing onto an 8" (20cm) rectangle of Arches 300-lb. (640gsm) cold-pressed watercolor paper.

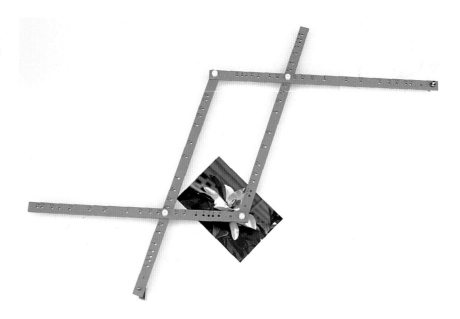

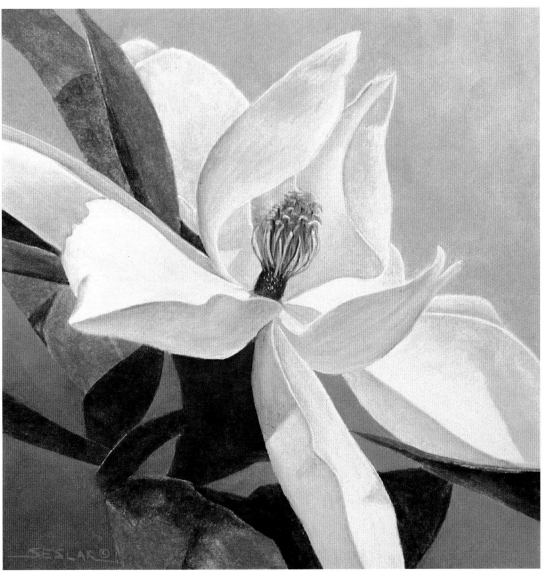

After masking out the blossom and leaves with liquid masking fluid, I painted the background as a graded wash using a 1-inch (25mm) flat brush and mixtures of Cobalt Violet, Chinese White, Cobalt Blue and Charcoal. When that dried, I removed the masking and used a no. 8 round brush to paint the leaves with mixtures of Olive Green, Burnt Umber, Charcoal and Naples Yellow. The blossom was painted with the same brush and mixtures of Naples Yellow, Yellow Ochre and Chinese White. This painting took two hours to complete.

TULIPS
Patrick Seslar
Watercolor on Arches 300-lb. (640gsm)
 cold-pressed watercolor paper
8" x 8" (20cm x 20cm)

Opaque Projectors

For anywhere from about thirty to three-hundred dollars, you can buy an opaque projector, which will project an image directly from a small 6" x 6" (15cm x 15cm) sketch or photograph directly onto your paper. The size of the projected drawing is easily adjusted by moving the projector closer to or farther from the paper you're drawing on. Most opaque projectors will project an image as small as the reference itself to one that is as much as ten times larger. On the negative side, opaque projectors cannot project from slides. They can also be hot and noisy in a confined space because the light is provided by a 300-watt bulb cooled by an electric fan. In addition, most opaque projectors only work decently in a totally darkened room and can only project a usable image about seven or eight feet. After that, the image becomes washed out and is difficult to see and trace. Even with their limitations, however, opaque projectors may be the simplest way for those with less-than-perfect drawing skills to enlarge from small sketches or photographic prints.

Slide Projectors

For $200 to $300, you can purchase a good slide projector that can project a crisp image from a 35mm slide for up to fifteen or twenty feet in a darkened or semidarkened room. As with opaque projectors, it's easy to alter the size of the projected image by moving the projector closer to or farther from the drawing surface. It's also easy to rearrange or resize elements from the same reference slide or to project additional elements from a second or third slide to create a composite drawing. You may need a special lens or adapter for reducing the size of the projected image, but you can avoid that expense by planning ahead. When you take reference slides, simply shoot a series—some closer and some from farther away—then choose the one that projects closest to the size you need. On the negative side, slide projectors cannot project photographic prints and, like opaque projectors, they do produce some heat and noise.

An opaque projector

This slide projector, made by Apollo Audio Visual, is both a slide viewer and a projector.

Timesaving Painting Techniques

Watercolor is as difficult as you make it, so why not make it easy? We've already discussed how simplifying the process of collecting and modifying references and enlarging your drawings can save you time, but now it's time to paint. So, what can you do to paint more quickly during your one-hour sessions? Again, keep things as simple as possible.

Use a Limited Palette

Art supply stores offer a cornucopia of wonderful colors from a variety of manufacturers, but the truth is simple: It's far better to work with a few colors that you know well than to have a box full of exotic colors that produce unpredictable results. You'll save time and money and you'll be far more likely to get the results you had in mind before you set paint to paper.

We touched on this topic in chapter 1 (see "Choosing a Palette: How Many Colors Are Enough?"), and you saw several examples of limited palettes and the wonderful variety of colors they could produce. Here is another example for you to consider:

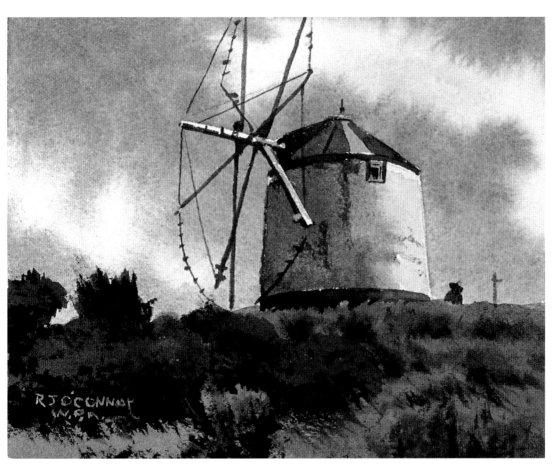

Two-Color Palette: Burnt Sienna and French Ultramarine Blue
After masking out the building with masking tape and cutting away the excess tape with a no. 11 craft knife, O'Connor used a 1-inch (25mm) flat brush to paint the sky wet-in-wet using mostly French Ultramarine Blue. Then, with the same brush, he began the foreground wet-in-wet using mostly Burnt Sienna. As the paper dried, he switched to a no. 6 round brush and used less and less water with the paint until he finished using nearly pure pigment. When the sky and foreground were dry, he removed the masking tape and painted the old mill with various mixtures of the two palette colors and the no. 6 round brush. This painting (including initial drawing) took one hour to complete.

OLD MILL, OBIDOS, PORTUGAL (#1)
Robert O'Connor
Watercolor on Arches 300-lb. (640gsm)
 cold-pressed watercolor paper
4" x 5" (10cm x 13cm)

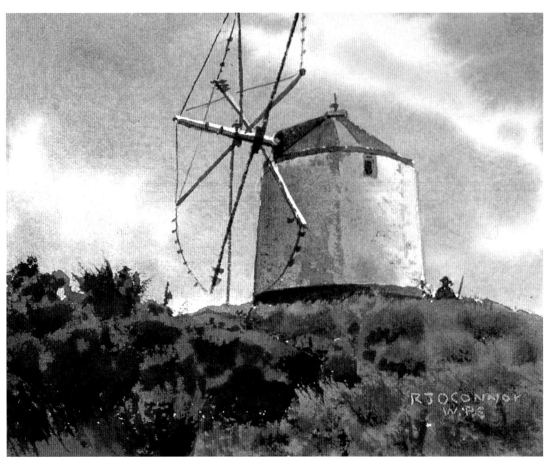

Three-Color Palette: Cobalt Blue, Burnt Sienna and Cadmium Yellow

This painting was executed in the same order and with the same brushes as *Old Mill, Obidos, Portugal (#1)*. The sky was painted wet-in-wet using Cobalt Blue and Burnt Sienna; the foreground was various mixtures of all three palette colors. This painting (including initial drawing) took one hour to complete.

OLD MILL, OBIDOS, PORTUGAL (#2)
Robert O'Connor
Watercolor on Arches 300-lb. (640gsm) cold-pressed
 watercolor paper
4" x 5" (10cm x 13cm)

Limit Values

Watercolor is a medium of nuance: A single stroke can contain many variations in color and value. That is why we don't often think of watercolor in terms of well-defined values that are easily distinguished one from another like so many steps on a staircase. A ten-value scale provides a useful way of visualizing values, but to paint more rapidly, we need to work with fewer values. Generally, about three values plus the white of the paper are sufficient to produce a credible image and still allow you to work swiftly. Even with ten distinct values, many watercolors suffer anemia from a poor distribution of values. So, in addition to speeding up the painting process, limiting your values will almost certainly clarify your painting's value structure and help you create stronger and more dramatic images. Here's an example of what I mean.

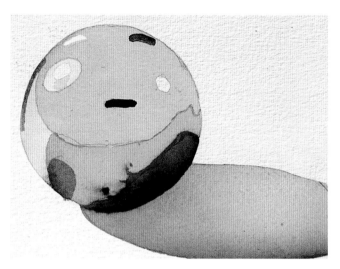

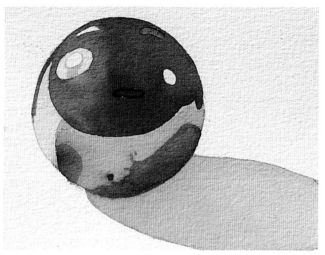

one Susanna Spann mentally classified the values in the marble into three ranges: light values (including the unpainted white of the paper), middle values and dark values (the darkest darks she can mix).

After deciding where to leave the paper blank for the lightest value, she painted the light values for each color in the marble wherever she identified them.

Spann's palette consisted of Antwerp Blue, Payne's Gray, Cobalt Turquoise and Rose Doré. From these colors, she mixed and applied various pale washes using Winsor & Newton Series 7 brushes (nos. 1 and 2). Spann allowed each area of color to dry before painting another adjacent area in order to keep the two colors from bleeding into each other.

two Following the same procedure as in the previous step and using the same brushes, Spann applied additional washes to create middle values for each of the colors in the marble wherever they appeared. "In order for glass to look like glass," says Spann, "it needs a full range of values and hard edges."

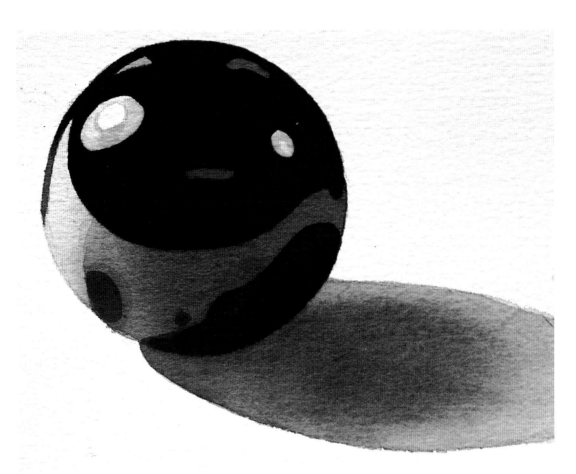

three Continuing in the same manner as in the previous step, Spann applied additional layers of color to create the darkest values wherever she saw them.

MARBLE
Susanna Spann
Watercolor on Arches 300-lb (640gsm) cold-pressed
 watercolor paper
6" x 6" (15cm x 15cm)

Quick and Easy Special Effects

After you've painted for a while, you'll begin to see the process differently. Rather than seeing a finished painting as a formidably complex montage of death-defying technical skills and crowd-pleasing pyrotechnic special effects, you'll come to see an image as a combination of simpler techniques that, together, produce a refined image. With that in mind, here are some key techniques to help you paint more quickly. You'll find some or all of them in every painting in this book. Remember, it's not magic, just sleight of hand! Let's have a look.

Illustration by Robert O'Connor

Flat Wash

This very even tone is useful for quiet backgrounds and for laying down an undertone over which other textures will be added later (the basic tone of weathered wood, for example, or the trunk of a tree). For this example, Robert O'Connor created a large puddle of Ultramarine Blue and Burnt Umber, which he applied with a 1-inch (25mm) flat brush using consecutive, slightly overlapping strokes. You may find that it helps to tilt the paper slightly as you work, particularly for larger washes.

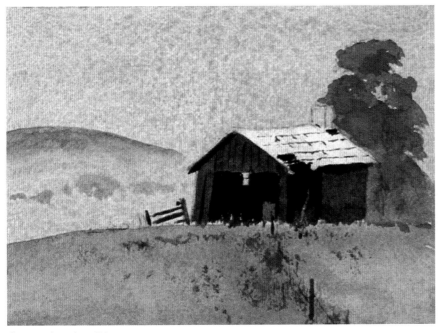

Illustration by Robert O'Connor

Flat Wash in Action

To add the foreground, O'Connor painted the field using Sepia and Raw Sienna. To paint the building, he masked the outside of the roof and walls with masking tape, then lifted the wash colors off with a damp brush. After removing the tape, he used a no. 6 round brush to paint the building and a suggestion of shingles with Sepia and Raw Sienna.

Graded Wash

Use this technique when you want a wash that gets lighter from top to bottom (or side to side depending on the situation). Apply it in the same manner as the flat wash, working from the top down on a slightly tilted paper with a 1-inch (25mm) flat brush. For a graded wash, however, add more water with each successive stroke to produce the graded tone. This takes practice, so be patient.

Variegated Wash

Some people call this a streaky wash. It is distinguished by the fact that the color or colors are unevenly applied. This technique is especially useful for suggesting soft, cloudy skies or diffuse backgrounds. For this illustration, O'Connor laid down a basic tone of Cadmium Red mixed with Burnt Sienna, moderated unevenly with touches of Ultramarine Blue.

Graded Wash in Action

Here's an example of one situation where a graded wash is useful. The lighter portion of the wash (bottom) makes a great foil to contrast against the sandbar and reflections of the boat. Graded washes are also useful for suggesting light and form for irregular shapes such as leaves and petals, or rounded objects, such as might appear in a still-life setup.

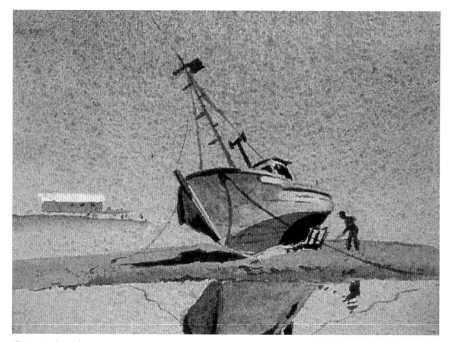

Illustration by Robert O'Connor

Drybrush

Almost any brush is capable of creating a dry-brush texture, so choose one that feels right for the area in question. To use this technique, remove most of the water from your brush by dipping it in the desired color then blotting it lightly with a paper towel. Next, drag the brush over the dry paper with its handle almost parallel to the surface. Once you get the hang of it, it's easy to create grasses or weathered textures. Take a look at Harry Thompson's demonstration in chapter 3 for more examples of this technique. He uses a no. 8 oil fan brush and a ½-inch (13mm) Loew-Cornell no. 7120 rake brush for this purpose. Again, the choice of brush is up to you.

| No. 1 fan brush | No. 8 round brush | 1-inch (25mm) flat brush |

Drybrush in Action

For this small color study, O'Connor painted a blue-gray sky onto dry paper. Next, he loaded a no. 12 round brush with a mixture of Raw Sienna and Burnt Sienna and lightly blotted it with a paper towel. Then, he dragged the brush diagonally upward across the paper, holding the handle almost parallel to the surface. This left a stroke of broken color that began denser at the bottom and gradually trailed off to a ragged edge of uneven parallel lines near the end of the stroke. After adding Ultramarine Blue to the mixture, he repeated the process to indicate the darker grasses.

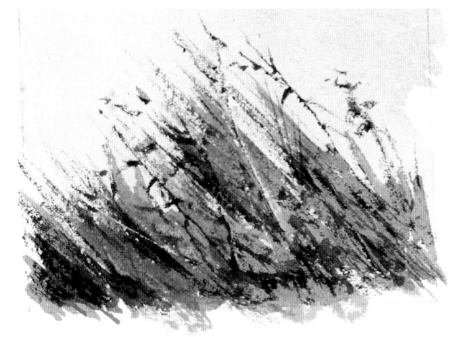

Illustration by Robert O'Connor

Spattering

Any stiff bristle brush or toothbrush can create a useful spatter pattern. Spattering is a great way to add texture to areas with boring, even tones or to suggest dirt or sand. Practice on scrap paper and use tracing paper to cover things you don't want spattered. Experiment by varying the amount of water in your brush. Try springing the bristles against your thumb or forefinger, or slap the brush ferrule against your hand to propel spatter droplets onto your paper. Have fun and wear clothes that don't matter!

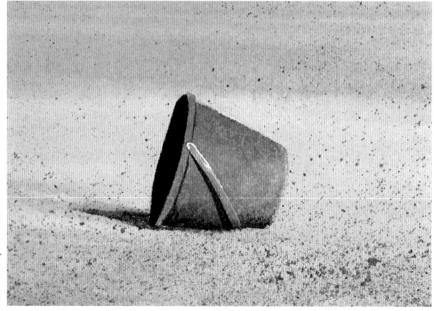

Illustration by Lin Seslar

Spattering in Action

In this example, my wife, Lin, first masked out the shape of the bucket with liquid masking fluid, then applied a subtly graded wash of Burnt Umber and Payne's Gray. When it dried, she spattered a medium tone of the wash color, followed by a darker version and then finished with a light tone created by diluting the wash color further with water. When the spattering was dry, she removed the masking and painted the bucket.

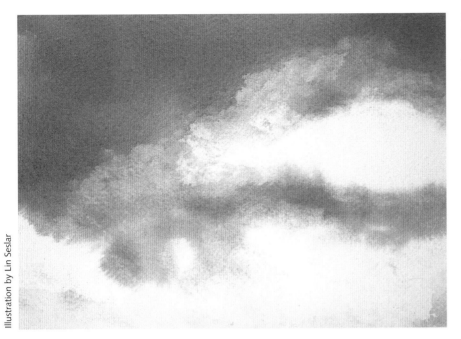

Lifting Out With a Paper Towel
In this example, Lin first painted a loosely graded wash of the sky color and then, while the wash was still wet, used a wadded paper towel to blot and lift color out of the wash to suggest cloud forms.

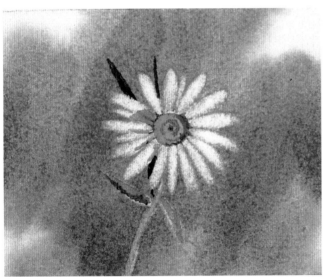

Lifting Out With a Brush
For this example, O'Connor lightly drew the flower shape, then dampened the whole area before applying a variegated wash using various mixtures of Burnt Sienna, Cobalt Blue and Cerulean Blue. All were chosen because they are nonstaining colors that could be easily lifted out when dry. When the wash was dry, he used a damp ⅛-inch (3mm) flat brush to lift out one petal at a time, cleaning and blotting the brush between lifting strokes. Once the color had been lifted out of the petals and center, he painted the details with Raw Sienna and Ultramarine Blue.

Masking Tape

Ordinary masking tape is a good and fast alternative to liquid masking fluid for well-defined shapes. There are three steps to follow to use masking tape for this purpose.

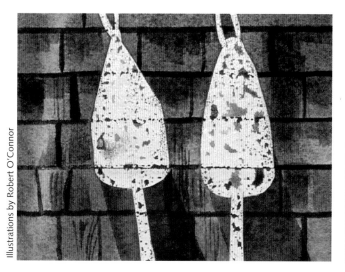

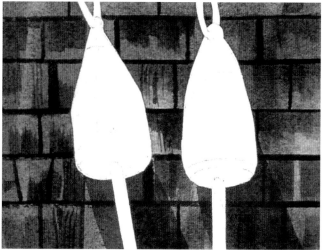

one First draw your subject dark enough that you can just see its shape through the masking tape once you've covered it. Next, use a sharp no. 11 craft knife to lightly cut around the shape. The goal is to cut through the tape without cutting into the paper. If you cut too deeply, paint will settle into the cut forming a dark line when you apply background washes.

two Once you've applied your background wash and any desired detailing, allow the paper to dry and then remove the tape to expose the reserved white of the paper.

Masking tape can also be used to recover the white of the paper by helping to lift a previously applied wash without disturbing surrounding color. To recover whites, surround the area of paint to be lifted with a "fence" of masking tape to protect it from damage. Masking tape provides a naturally straight edge when recovering whites for buildings, for example, but works equally well for recovering whites within irregularly shaped areas. In either situation, to recover whites, instead of peeling away the surrounding tape, simply cut and peel away the tape covering your drawing (rather than the surrounding tape as you would when using it to preserve white). Then, use a damp brush to lift the colors and recover the white of the paper.

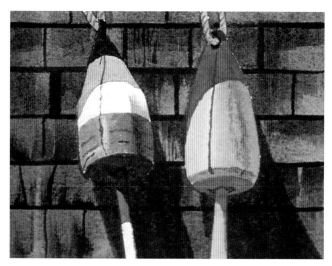

three With the tape removed, simply paint the objects as you would ordinarily. That's all there is to it!

Salt Texture

To create an interesting and somewhat unpredictable texture, try adding salt to a freshly applied wash just as the wet sheen disappears from the paper. It will take a few minutes for textures like this to begin to appear. Not all colors react in the same way and the texture will vary depending on how wet the paper is when you sprinkle the salt. Use scraps of watercolor paper liberally to test various colors and how they react to salt in a damp wash.

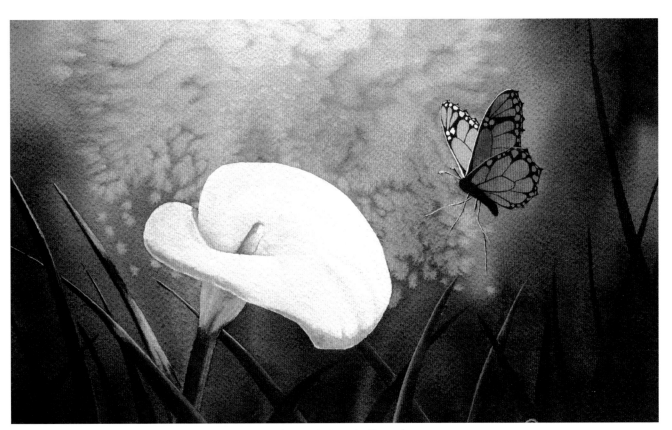

To create the salt texture in the background of this painting, I first masked out the flower, its stem and the butterfly with liquid masking fluid then applied the wash of Sap Green, Sepia and Charcoal. Just as the wet sheen disappeared, I sprinkled salt onto the paper. Later, when the paper had dried completely, I brushed the remaining salt crystals off of the paper, removed the masking and painted the flower and butterfly.

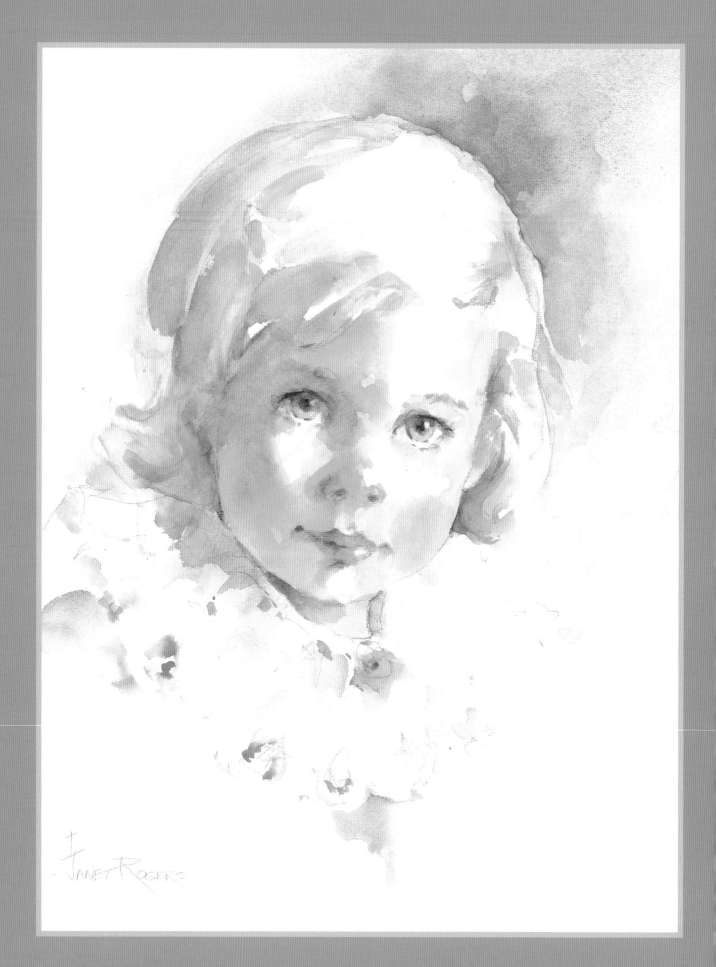

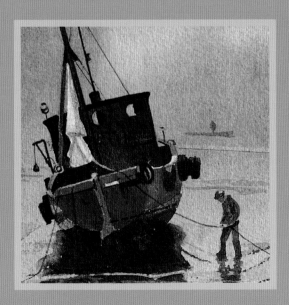

STEP-BY-STEP DEMONSTRATIONS

If you think the concept of creating wonderful paintings in one hour is too good to be true, here's the "proof of the pudding," so to speak. In this chapter, you'll look into the studios of twelve artists (myself included) to see what each was able to accomplish in one hour of painting and how he or she went about it.

As I said at the beginning of this book, it's okay to do some advance preparation for your one-hour painting session. That way, you can approach your painting time with joy and anticipation, knowing you won't be unceremoniously yanked out of the mood by unresolved issues of drawing, composition or paper that wasn't ready to receive paint. To help you better understand how to eliminate these types of mood-wrecking obstacles, several of the demonstrations include details showing how artists kept the focus on painting by resolving details of sketching and paper stretching prior to their painting sessions.

3

Small Scale, Big Impact

*m*any people ask Pamela Jo Ellis why she doesn't paint bigger. "I tried quarter sheets," she says, "but it just wasn't how I saw things… When I look at other artists' paintings, I am always drawn to the small ones—the ones that just capture one moment, one item, one instant, all in front of you to absorb. The artist's ability can be appreciated, not the hugeness of the composition but his brushwork, his use of color, his finesse. An image doesn't gain importance when rendered on a large scale—it's the quality of the rendering… ."

And what secret allows Ellis to create such a big impact with such small images? "I look very carefully at the scene I'm trying to capture," says Ellis, "keeping the focus simple, looking for color contrasts, finding the really dark darks … these make the compositions pop for me. I never make up a scene; all my images are real places, real moments."

"In all my work," Ellis says, "I try to capture the way a moment feels. I try to grab the viewers so they'll involuntarily take a breath, smell the air or close their eyes to feel the wind. In *Winter Maple*, I wanted to capture the coolness of the snow, with its overall 'blueness' broken only by the slight warmth of the brown tree branches and strong trunk."

How to Balance Branch Forms

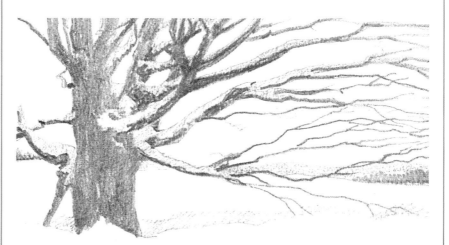

In this example, Ellis used a 2B pencil to render a realistic branch pattern for a maple tree. From a design standpoint, however, she felt that the branches were too regular in both angle and density. She also felt that they carried the viewer's eye out of the image.

UNTITLED PENCIL SKETCH
Pamela Jo Ellis
Drawn on Arches 140-lb. (300gsm)
cold-pressed watercolor paper
2½" x 4½" (6cm x 11cm)

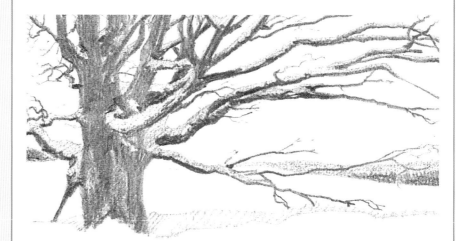

In the second sketch, Ellis kept the branching pattern irregular, consciously varying the distances between major branch forms and varying the angles of individual branches. She also added smaller, twisting branches to the left of the trunk, using their complex forms to balance the simpler, elongated branches that dominate the right side of the composition.

UNTITLED PENCIL SKETCH
Pamela Jo Ellis
Drawn on Arches 140-lb. (300gsm)
cold-pressed watercolor paper
2½" x 4½" (6cm x 11cm)

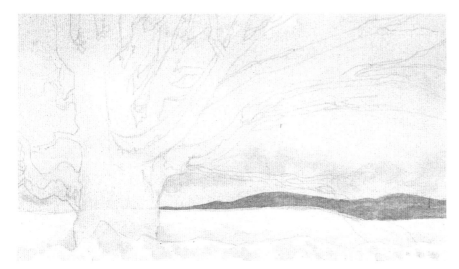

one (TWENTY-TWO MINUTES)Ellis began by drawing a 2½" x 4½" (6cm x 11cm) rectangle on the top sheet of a block of 140-lb. (300gsm) Arches cold-pressed watercolor paper (see chapter 1) with a 5H pencil. After sketching the tree shape and background elements (SEVEN MINUTES), she "tweaked" the branch patterns and indicated the whites of snow left on the branches (THREE MINUTES). Finally, she taped off the edges of the rectangle with white acid-free artist's tape.

Ellis prepared to paint the sky by mixing two pools of color—the first, a pale pool of Cerulean Blue and French Ultramarine Blue, and the second, a separate pool of Alizarin Crimson and French Ultramarine Blue (TWO MINUTES).

Next, working on dry paper, Ellis used a no. 10 Winsor & Newton Series 233 brush to lay in the first sky washes. Starting at the top of the painting, she applied a wash of the blue mixture over one-third of the sky area. Next, she switched to plain water for one brushstroke, then continued with the Alizarin mixture almost to the mountain. Adding more Cerulean to the blue mixture, she brought the wash down through the mountain and distant trees to where the sky meets the snow so no visible line could be seen later. "As the wash dried," says Ellis, "I drybrushed in more Cerulean Blue with a dash of Payne's Gray above the distant mountains to indicate an area of denser clouds. Then, I dabbed the area of plain water with a dry rag to keep the colors from running into the lightest part of the sky" (THREE MINUTES).

As the sky dried, Ellis developed the foreground. Using a no. 6 Holbein Eldorado HX brush and a diluted mixture of the blues, she added loose shadows to the snowy fields near the tree base and in the snowbank at the bottom. Adding Burnt Umber to the blue mixture, she dabbed color in the foreground using the same brush, keeping it very dry to give a feeling of dirt on the snow (FOUR MINUTES).

After a short break to allow the wash to dry slightly, Ellis painted the distant hills using a no. 3 Winsor & Newton Series 233 brush and a denser mixture of French Ultramarine Blue and Cerulean (THREE MINUTES).

two **(Eleven minutes)** Adding a little Naples Yellow to the mixture, Ellis painted the backlit snow on the branches. Then, making the mixture slightly denser, she painted the trunk and branches.

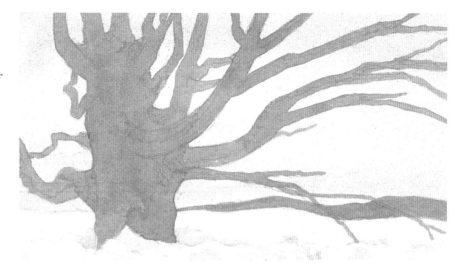

three **(Thirteen minutes)** "At this point," says Ellis, "I restated the outlines of areas where snow would be left on the branches because these 'left-alone' areas give the tree form and depth" **(three minutes)**.

Next, with a dense mixture of Burnt Umber, French Ultramarine Blue and Payne's Gray and a no. 3 Winsor & Newton Series 233 brush, Ellis blocked in the dark of the tree, carefully reserving the blue snow patches and developing detail at the ends of the branches. Then, continuing with the same brush and a lighter (more dilute) version of the tree color, Ellis filled in details of the background trees on the far hillside using a no. 00 brush so old that most of the outer bristles had worn away leaving an almost perfect point. Finally, Ellis added a thin glaze of Cerulean Blue over the background hill to make it appear bluer than the background sky **(ten minutes)**.

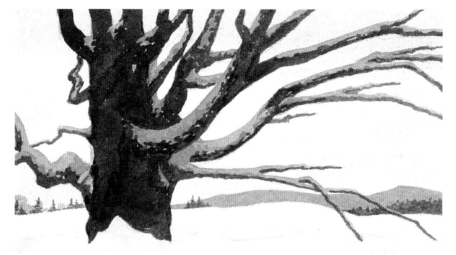

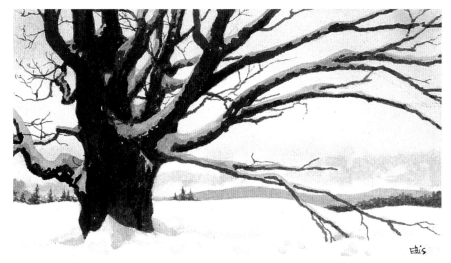

WINTER MAPLE
Pamela Jo Ellis
Watercolor on 140-lb. (300gsm)
cold-pressed watercolor paper
2½" x 4½" (6cm x 11cm)

four (SEVENTEEN MINUTES) Using Cerulean Blue and a dry-brush technique, Ellis accentuated the cloud layer above the hill. In the reference photograph, the branches on the right were nearly obscured by other foliage and further confused with an uninteresting fence. "To finish these branches," says Ellis, "I went by feel and design, not letting any pattern take over, keeping things uneven. I was especially careful with the tiny branches to the left of the trunk, adding just the right amount of detail to balance them with the ones that reach to the right to keep the composition from falling off the page" (ELEVEN MINUTES).

To complete the painting, Ellis darkened the tree mixture further with French Ultramarine Blue and suggested a bark pattern on the heavy trunk using a no. 3 Winsor & Newton Series 233 brush. Finally, with the same brush, she added strokes of this same color on some of the larger branches to darken them so they would appear to recede behind others in the confusion of branches near the base of the tree (SIX MINUTES).

TOTAL TIME TO COMPLETE: ONE HOUR AND THREE MINUTES.

The Whole Is the Sum of the Parts

*t*here are many ways to adapt one-hour watercolorists' techniques to your personality and painting habits. For example, some artists work quickly, while others pursue a more time-intensive approach. Susanna Spann falls solidly into the latter group: Her most complex images are created via a series of sessions that often entail spending as many as one-hundred hours of one-hour sessions for a single painting. If you are at all like her, you may find that the following approach works well for you.

When a subject is complex and your style or technique is time-intensive, try breaking the image into smaller, individual paintings that can be completed in one-hour sessions. Then later, as you have time, you can assemble the knowledge and experience you've gained into larger, more complex images that can be painted using a series of one-hour sessions, each devoted to painting single elements that you've worked out previously. The major difference between the final complex image and the simpler individual paintings will be that the individual elements appear together as a unified composition rather than as stand-alone subjects.

So, let's see how it works. *Crystal Bird* took one hour to complete.

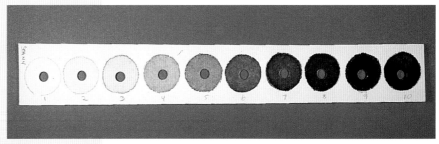

You may want to create a sample value scale such as this for your own reference when approaching a painting in the manner Spann describes. Value 1 is the white of the paper; value 10 is the darkest dark she can mix.

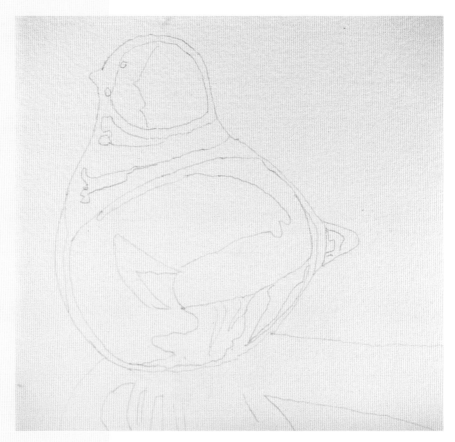

one **(FIVE MINUTES)** Spann used a no. 2 office pencil to lightly indicate the bird's shape on a 6" x 6" (15cm x 15cm) piece of unstretched Arches 300-lb. (640gsm) cold-pressed watercolor paper. Next, she mentally noted the location of each value in the crystal bird using numbers ranging from 1 (the unpainted white of the paper) through 10 (the darkest dark she can mix). Then, she added lines within the bird's shape to identify where each value in the range appeared within the form. (See the illustration of the value scale Spann uses.)

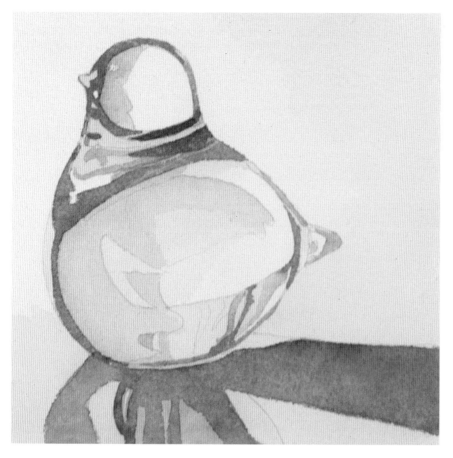

two (TWENTY MINUTES) Spann quickly identified the areas containing the lightest values (i.e., the no. 1 and no. 2 values). Naturally, since the no. 1 values are represented by the white of the paper, they were left unpainted. The no. 2 values of all colors were painted using various pale mixtures of Yellow Ochre, Payne's Gray, Burnt Sienna, Antwerp Blue, Rose Doré and Winsor Red. These mixtures were applied with Winsor & Newton Series 7 round brushes in size nos. 1, 2 and 3.

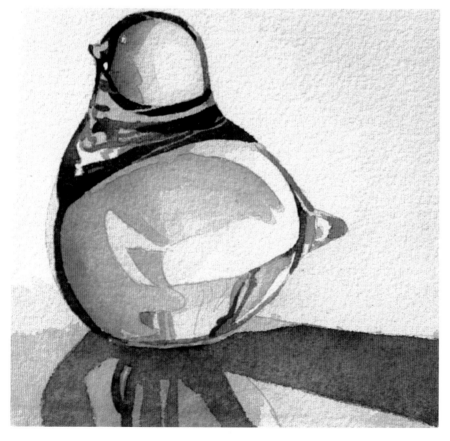

three (FIFTEEN MINUTES) Spann continued painting with the same brushes, adding additional layers of the same color mixtures as before to create the next sequence of darker values (nos. 3, 4, 5 and 6) for each color wherever they appeared in the painting.

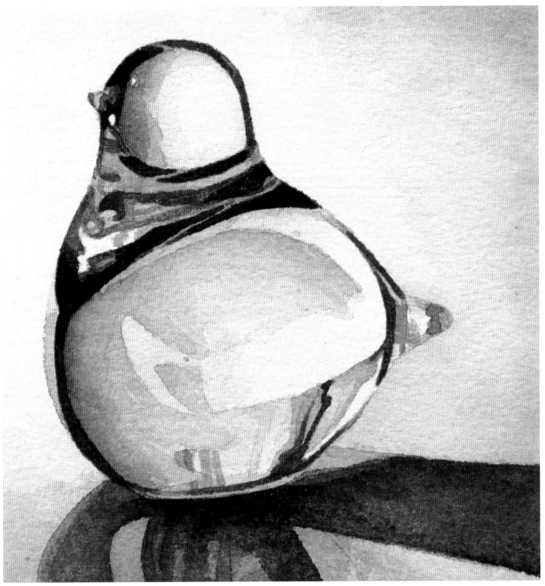

four **(TWENTY MINUTES)** Spann completed the painting by adding the remaining values (nos. 7 through 10) wherever they appeared, using the same technique as in the preceding steps.

TOTAL TIME TO COMPLETE: ONE HOUR.

CRYSTAL BIRD
Susanna Spann
Watercolor on Arches 300-lb. (640gsm)
cold-pressed watercolor paper
6" x 6" (15cm x 15cm)

Paint Your Own Backyard

O vercoming procrastination when you have a limited amount of time to paint is always a challenge, but you can make the task easier by choosing subjects that are familiar and close to home. In *Best Friends*, Harry Thompson has done just that. Having spent many summers in Maine, Thompson has seen, and sat in, Adirondack chairs like these on many occasions over the years. He knows what it feels like to sit in one on a lazy afternoon. He knows the sensation of sun-warmed slats against his back and the mingled fragrances and rich colors of evergreens, flowers and new-mown grass. Here's how he captured all this and more in just one hour.

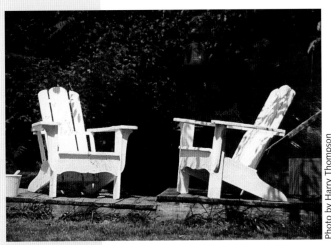

Photo by Harry Thompson

This is a photograph of the setting that inspired *Best Friends*. As you compare the finished painting with this photograph, you can see that Thompson has already visualized his basic composition using the viewfinder of his camera. Still, reality left a lot to be desired. Thompson's challenge was to bring this promising but rather drab image to life so that it would evoke all the feelings of warmth, color and fragrance that had made the actual scene so appealing.

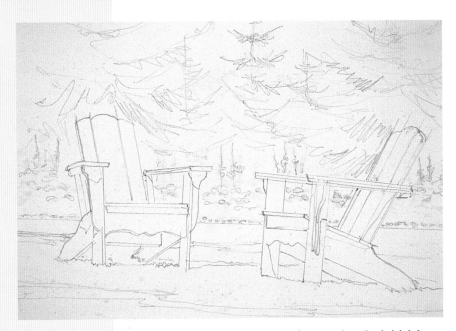

one (TWELVE MINUTES) After creating the initial drawing on Strathmore bristol plate 3-ply paper with a 2H pencil, Thompson masked off the flowers with Winsor & Newton colorless masking fluid.

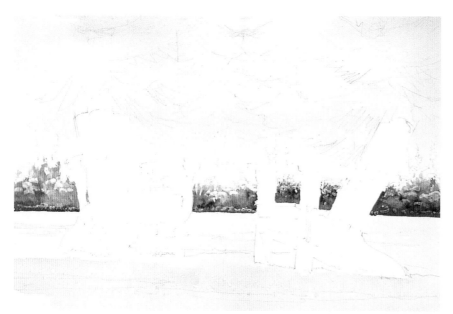

two **(TWELVE MINUTES)** When the masking was dry, Thompson used 1-inch (25mm) and ½-inch (13mm) brushes as needed to apply a wash of Cerulean Blue to portions of the sky, carefully avoiding the chairs. Continuing with the same brushes, he applied a thin wash of Winsor & Newton Transparent Yellow over the remainder of the paper (with the exception of the chairs), thereby establishing a feeling of warmth and giving his center of interest, the chairs, a well-defined form. Finally, he added the first hints of green in the flower bed using a Loew-Cornell Series 7020 no. 6 round brush and mixtures of Olive Green, Winsor Blue and Warm Sepia.

three **(TWELVE MINUTES)** To begin building the illusion of depth, Thompson painted the shadowed areas of each chair using a gray mixed from Cerulean Blue and Burnt Sienna. Next, he used the dark green mixture from the previous step to separate the flowers and background trees with a dark irregular line. As that dried, Thompson began establishing grass texture in the foreground using the stiff bristles of a no. 8 oil fan brush. For the grass around the chairs, he used the same colors and a ½" (13mm) Loew-Cornell no. 7120 rake brush.

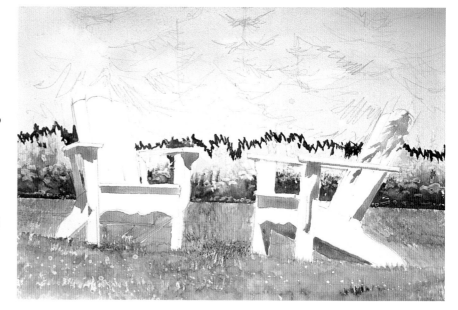

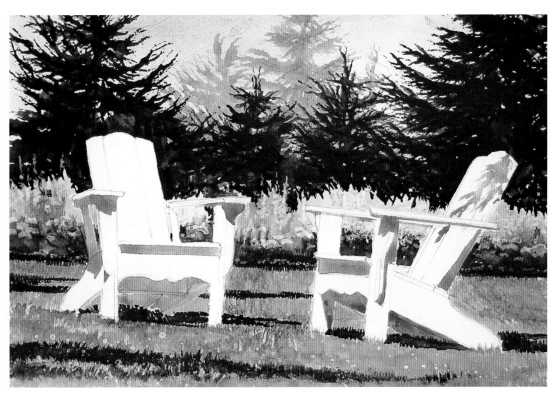

four (TWELVE MINUTES) Thompson continued building the illusion of depth by painting the distant background trees using a Loew-Cornell Series 7020 no. 6 round brush and a feathering stroke (see the sidebar "Creating Distant Foliage") to apply bluish mixtures of Cerulean Blue and Olive Green. As the distant trees dried, Thompson painted the cast shadows across the foreground and the cast shadows of the chairs using a ½-inch (13mm) rake brush and a mixture of Olive Green and Winsor Blue with a touch of Warm Sepia. Then, using the same dark mixture modified with more Warm Sepia, he painted the darker trees just behind the flower bed using the same feathering stroke as before. Finally, he "broke" the edge where the flowers and darker background trees met by applying a wash of Winsor & Newton Transparent Yellow. This wash warmed and unified the flower bed and at the same time produced a variety of green tones.

Creating Distant Foliage

Here's a simple way to suggest the feathered edges of the distant trees. Hold a no. 6 Loew-Cornell Series 7020 brush thickly loaded with color almost vertical to the paper and then push straight down while painting with the back edge of the brush.

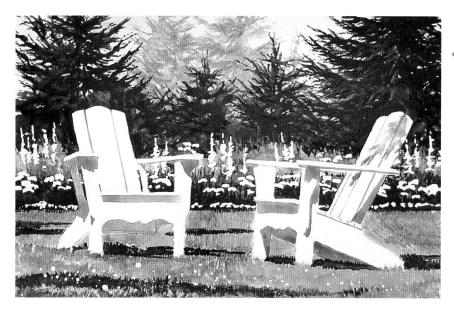

five **(TWELVE MINUTES)** After drying the washes from the previous step with a hair dryer, Thompson removed the masking.

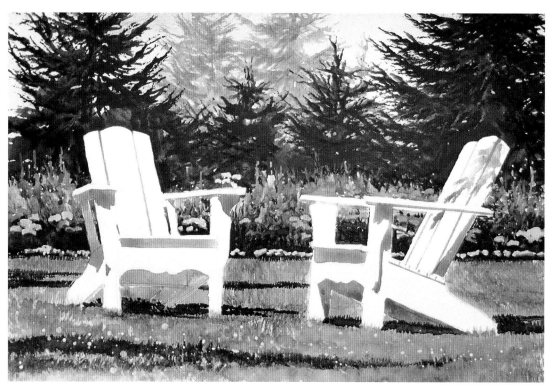

To complete the painting, Thompson painted the flowers using a no. 6 round brush and an assortment of all the extra bright colors from his palette.

TOTAL TIME TO COMPLETE: ONE HOUR.

BEST FRIENDS
Harry Thompson
Watercolor on Strathmore
 bristol plate 3-ply paper
6½" x 9½" (17cm x 24cm)

Divide and Conquer

*C*reating portraits of family members can be a satisfying way to develop your one-hour painting skills. When nieces, nephews, grandparents and grandchildren are included as possible subjects, you have a treasure trove of wonderful references that's usually willing and close at hand. What's more, extensive photo reference is often as close as your coffee table in the form of scrapbooks or in your closet in shoeboxes of family photographs. Either way, having so much reference material eliminates one major barrier to getting started—finding suitable subjects. The seeming magnitude of the task can often be a barrier, as well, but as Janet Rogers shows in this demonstration, with a little planning, you can divide the project into manageable one-hour sessions.

When Rogers paints portraits of her two granddaughters, Cassandra and Victoria, she frequently uses the "divide and conquer" approach (see chapter 1, "Divide and Conquer: Strategies for More Complex Subjects in One-Hour Sessions") to get into the rhythm of painting and have fun while she's at it. For her this means spending about an hour doing preparatory work: picking out a suitable photograph, doing a few quick pencil sketches and a color study/sketch. The culmination of her first hour's effort in this instance is a beautiful and wonderfully spontaneous portrait that any artist would be proud to complete in so short a time. Still, Rogers wanted to try a more developed version of the portrait. Having completed her sketches, color study and the initial drawing for the more finished painting during the first hour, she was able to spend her entire second hour painting.

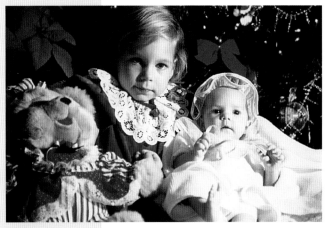

Preparations

"Because children are so active," says Rogers, "I take many photographs, hoping to find one that 'clicks.' I look for a nice light pattern," she says, "preferably with natural light coming from one direction, a little above and to one side of the subject. Basically, I look for a photograph that 'speaks' to me—one with a good natural expression and eyes that are open enough but not squinty."

one **(ONE TO THREE MINUTES)** Using a 4B pencil for drawing and a kneaded eraser for corrections, Rogers always starts with a quick gesture sketch.

two (FIVE MINUTES) Using the same pencil, Rogers continues her warm-up with a contour drawing (five minutes), drawn while looking at the photo and not at the paper, because doing so makes her look more carefully at the character and features of each subject. "These sketches look funny," says Rogers, "but they should!"

three (FOUR TO FIVE MINUTES) Rogers spends a few more minutes creating a "rhythm" sketch, again with a 4B pencil. "The idea," says Rogers, "is that after you've drawn the gesture and contour sketches, you'll fall into a natural rhythm for this final exercise. Once you recognize your subject on paper, you're ready to draw on the watercolor paper."

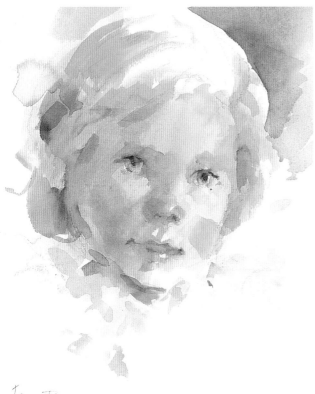

four **(Fifteen to twenty minutes)** With this color sketch, Rogers roughly approximates the colors she'll use in the final painting. Having completed her preliminary pencil and color sketches, she has determined what she will paint and how she'll approach it. Now, once she completes the initial drawing for the finished painting, she'll be free to spend her next one-hour painting session concentrating solely on painting.

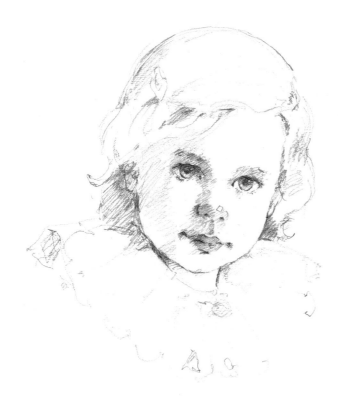

five **(Approximately thirty minutes)** Rogers says, "I like to get in some of the shadow shapes so I can see the connections between the lights and darks—the composition of the painting. I also draw enclosures where I want to keep the paper pure white. These are usually the highlights— the 'catch light' in the eye, the little highlight on the nose, the sparkle in the lips. Finally, I use a kneaded eraser to lighten or eliminate any lines or marks from the 4B pencil that I do not need."

one (**Twenty minutes**) For this painting, Rogers chose a 19" x 15" (48cm x 38cm) piece of Fabriano Artistico 300-lb. (640gsm) cold-pressed watercolor paper taped to a drawing board and positioned at a 45 degree angle so that colors would flow and mingle more easily. Starting with the paper completely dry, she mixed several puddles of warm and cool colors on her palette, then began applying color. For the shadowed side of the face, she used a Loew-Cornell Series 7700 no. 26 round brush to apply a wash of Raw Sienna, followed by carefully placed washes of Cobalt Violet, Cerulean Blue, Greenish Yellow and Scarlet Lake (around the cheek area). She then added hints of these same colors selectively to the illuminated side of the face as well as to the hair and collar. Smaller details such as the eyes and decoration at the center of the collar are roughed in with other palette colors and a Loew-Cornell Series 7020 no. 14 round brush.

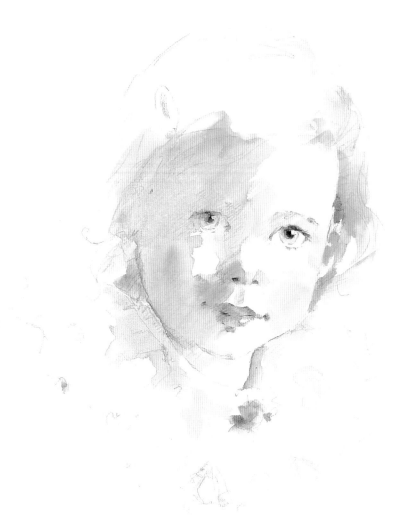

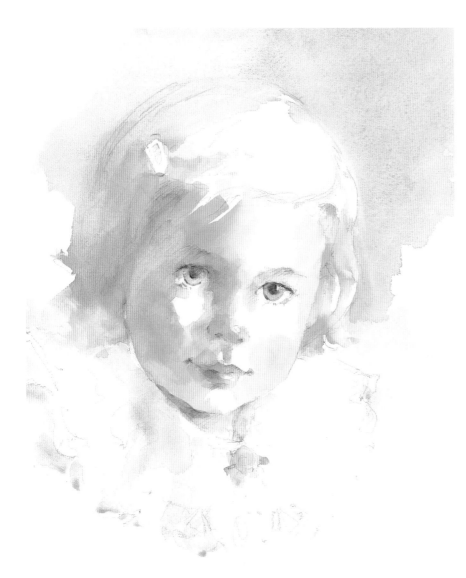

two **(Twenty minutes)** After allowing the first washes to become bone dry, Rogers began "bringing the composition together" by putting in the background and trying to pull values together to create big shapes. "As I lay in the background," says Rogers, "I like to let some of the color seep into the hair so that it avoids a cutout look. I restate and refine the shadow shape on the face to make it a bit stronger, but I'm still not concerned about refining details at this point."

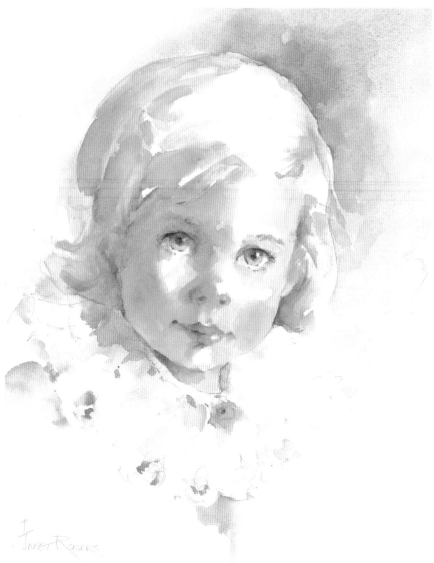

CASSANDRA
Janet Rogers
Watercolor on Fabriano Artistico 300-lb. (640gsm)
 cold-pressed watercolor paper
19" x 15" (48cm x 38cm)

three **(TWENTY MINUTES)** To complete the painting, Rogers strengthened values overall and continued to adjust colors. The background washed in during the previous step didn't seem strong enough, so Rogers added Cobalt Blue, which seemed to provide a better contrast with the blonde hair and helped bring the head forward in space. Accents of Cobalt Blue were also added to the collar to provide color harmony with the background. Finally, values and colors in the shadow side of the face and in the eyes were once again adjusted and strengthened.

"I adjust values until I feel I've said 'enough,'" says Rogers, "being careful not to overdo the details. I try to think in terms of big shapes, subtly adjusting values and colors within them. By not overworking the details, I try to keep my paintings looking spontaneous and alive."

TOTAL TIME FOR PREPARATIONS: APPROXIMATELY ONE HOUR.

TOTAL TIME TO COMPLETE PAINTING: ONE HOUR.

Creating Large and Small Wonders With One Brush

*e*arlier in the book we asked, "How many brushes do you really need?" I'd always found that five brushes seemed to meet all my needs, but I'll admit that even I was surprised by the answers I received from the artists who contributed to this book. Even for quite large paintings, they often relied on three or fewer brushes to create truly wonderful images. Quite aside from the space and cost savings, keeping your selection of brushes simple is a great idea because it also removes another opportunity for indecision and procrastination during the valuable minutes of your one-hour sessions: deciding which brush to use.

To give you a better idea of what can be accomplished with a minimum selection of brushes, let's look at Carmen Lagos's *Banana Blossom*, which took one hour and three minutes and was painted almost entirely with one brush: a no. 12 Kolinsky sable! "Working with one large brush keeps the strokes larger and somehow simpler," says Lagos, "and, believe it or not, this even makes painting details simpler."

Using a large brush also complemented Lagos's approach to this subject. "I was more interested in the abstract patterns created by the portions of the big leaves and by the blossom than in specific details. I wanted to capture the beauty of it without having to paint the whole plant," says Lagos.

one (TEN MINUTES) For *Banana Blossom*, Lagos selected a 13" x 9½" (33cm x 24cm) piece of Arches 300-lb. (640gsm) cold-pressed watercolor paper and, using a 35mm slide for reference, drew her subject in pencil. Next, she applied Winsor & Newton colorless masking fluid along the edges of the main stem and to the bunch of fibers on its left (near the center of the image) using an old brush dipped in soapy water. Lagos did not stretch or tape the paper down prior to painting.

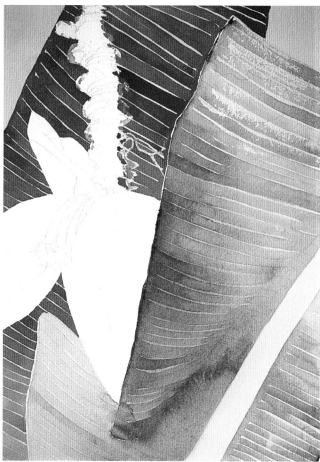

two **(ELEVEN MINUTES)** Using a no. 12 Kolinsky sable brush, Lagos applied a wash of Winsor Yellow and Raw Umber over most of the image with the exception of the light-struck portions of the leaf on the right, the stem and the blossom. Using the same brush, she drybrushed a mixture of Burnt Sienna and Alizarin Crimson along the edge of the foreground leaf to suggest aging and to create a strong diagonal in the composition. Finally, she added a dilute wash of Ultramarine Blue to the foreground leaf to create texture and help visually separate the various leaves from each other.

three **(TEN MINUTES)** Continuing with the same brush, Lagos added details and color to each of the leaves. To provide contrast, she painted the large leaf behind the blossom with a mixture of Alizarin Crimson and Burnt Sienna. For the lower portion of the same leaf, she used mixtures of Winsor Yellow and Raw Sienna. To develop the details of the foreground leaf, she used diluted washes of Sap Green, Winsor Yellow and Ultramarine Blue. To complete this step, she added washes of Burnt Sienna and Olive Green to the lower portion of the foreground leaf.

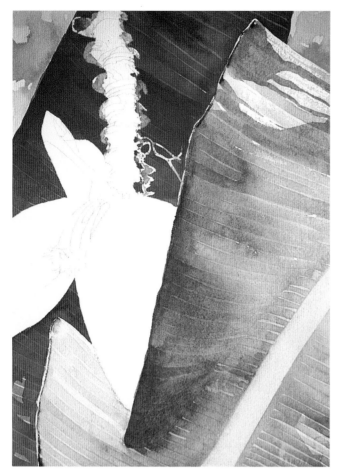

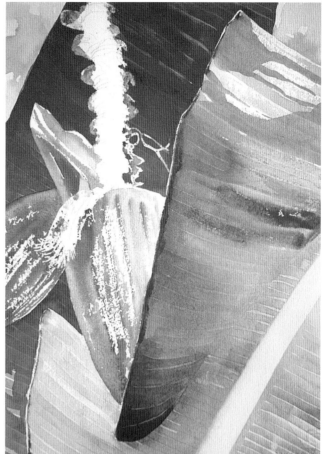

four (TEN MINUTES) Next, Lagos added textural strokes to the top left and right corners of the painting using mixtures of Olive Green with a hint of Burnt Sienna. Refining the red leaf further, she added another wash of Alizarin Crimson, Winsor Yellow and a touch of Ultramarine Blue to reduce distracting texture and to increase the color and value contrast at the center of the image. She also strengthened the value and color of the foreground leaf and reduced its texture using mixtures of Winsor Yellow and Raw Sienna. Again, all washes were applied with a no. 12 Kolinsky sable brush.

five (TEN MINUTES) Lagos continued developing the red leaf, adding stronger accents of Ultramarine Blue near the top. Next, after peeling off the dried masking fluid from the bunch of fibers near the center of the blossom, she painted the blossom using mixtures of Ultramarine Blue and Alizarin Crimson applied with a dry-brush stroke. While the paper was still damp from these strokes, she returned with additional dry-brush strokes using the same mixture as before with touches of Cerulean Blue added. Note that the masking remained in place on the stem.

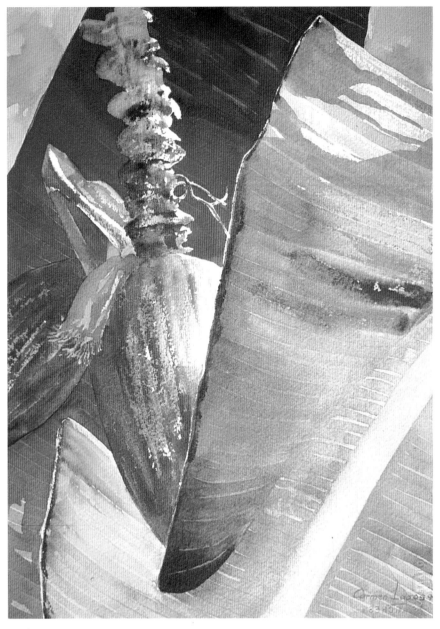

BANANA BLOSSOM
Carmen Lagos
Watercolor on Arches 300-lb. (640gsm)
cold-pressed watercolor paper
13" x 9½" (33cm x 24cm)

six (TWELVE MINUTES) Working with the same colors as in the previous step, Lagos added two additional layers of color to the blossom to build a sense of shape and volume and define the area where the light is strongest. With the blossom complete, Lagos peeled the dried masking fluid from the stem. Then, she used mixtures of Burnt Sienna, Raw Sienna and Ultramarine Blue to develop it in the same way as the other portions of the painting: a first layer to define light and shade, followed by additional layers to build and emphasize textures using dry-brush and wet-in-wet washes. Final details of the fibers hanging to the left of the blossom just below the stem were painted using a no. 6 Kolinsky sable brush.

TOTAL TIME TO COMPLETE: ONE HOUR AND THREE MINUTES.

Use a Limited Palette to Save Time

m any artists feel they need a paint box filled with every conceivable hue from every manufacturer to create all the colors they see in their subjects or merely to assure that their paintings are "interesting." In some cases, having a larger palette is definitely an asset, but when time is short, using a palette limited to three or four versatile colors makes great sense. A limited palette practically assures color harmony since the same few colors are present in almost every mixture in the completed painting. A limited palette also means you'll need to spend less time pondering how to mix colors and more time actually painting.

In *Waiting for the Tide*, Robert O'Connor used a limited palette to simplify and speed the painting process. The limited palette was a perfect choice for capturing the mood of a boat listing on a muddy beach awaiting the incoming tide; all around it, an early morning fog heavily laden with moisture shrouds the boat as the sun struggles to break through. The effect is so successful that you can practically hear the stillness, broken only by the echoing cries of seagulls wheeling in the distance and an occasional muffled splash as the fisherman steps to and fro adjusting the mooring line. This painting required about thirty minutes of prep time for color and value sketches and transferring the drawing onto watercolor paper. The actual painting took one hour exactly.

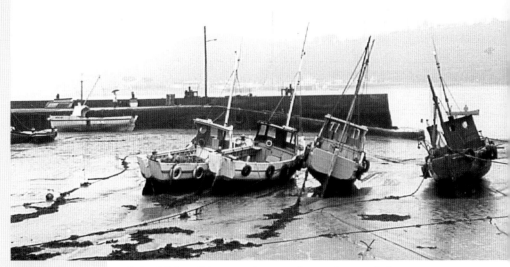

While on a painting trip to Ireland, Robert O'Connor took many reference photographs for use when he returned to his studio in Pennsylvania. This photograph has many possibilities and could be used in a variety of ways to create any number of unique compositions. For this demonstration, however, O'Connor decided to focus on the red boat on the right.

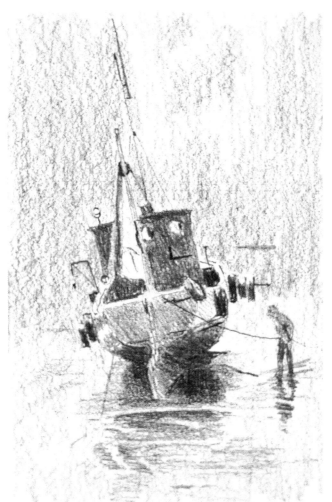

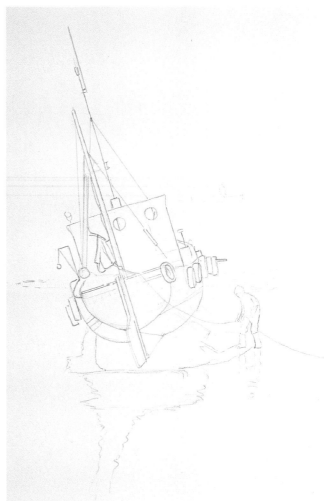

one **(Five minutes)** O'Connor spent about five minutes using a 6B pencil to create a 5" x 3" (13cm x 8cm) pencil sketch (as he nearly always does) to establish a plan for the values and their placement in the image. To make the composition more interesting, O'Connor added a man standing to the right of the boat, another rowing a dinghy in the distance and a few birds circling overhead.

two **(Twenty minutes)** Once satisfied with the value sketch, O'Connor drew a larger 11" x 7½" (28cm x 19cm) version on tracing paper. After making corrections or adjustments, he transferred the drawing and the rectangle marking its margins onto a 15" x 11" (38cm x 28cm) piece of Arches 300-lb. (640gsm) cold-pressed watercolor paper.

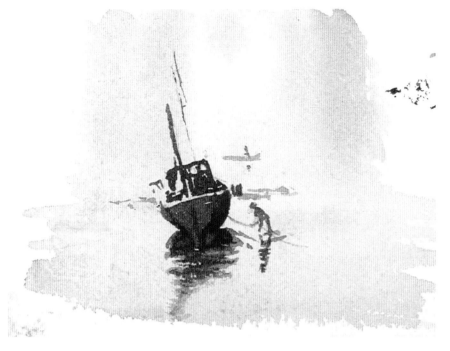

three **(FIVE MINUTES)** Prior to starting the full-size painting, O'Connor completed this small color sketch to test the palette of colors he had in mind.

Painting

one **(TEN MINUTES)** Before beginning to paint, O'Connor first masked off the outer edges of the image with masking tape. To preserve the white of the paper on the stern of the boat, the small sail just above it and one small spot high on the mast, he masked those areas with strips of masking tape. Then, he used a sharp no. 11 craft knife to carefully trim and lift away excess tape from around each shape. "I buy masking tape at an automotive supply store," says O'Connor, "because the tape they use for painting and striping cars adheres better. With cheaper masking tape from the hardware store, I've found that paint often leaks under the edges."

O'Connor next used a 1¼-inch (32mm) flat brush to wet the paper with clean water and then establish a loose background using a washy mixture of Yellow Ochre, Payne's Gray and Brown Madder Alizarin, allowing the colors to bleed up and down the paper.

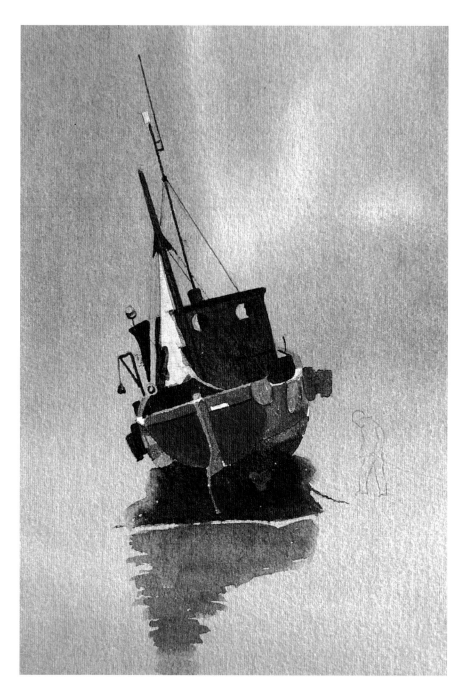

two **(Thirty minutes)** After drying the first washes with a hair dryer, O'Connor used a Robert Simmons no. 6 round brush to paint the large masses of the boat using various mixtures of Ultramarine Blue, Burnt Sienna and Brown Madder Alizarin (plus Cadmium Red for the hull). He used the same colors to block in the boat's reflection on the wet mud. O'Connor painted the dark tires using Ultramarine Blue and Burnt Sienna; for the dark shadows under the boat, he added Brown Madder Alizarin to the mixture.

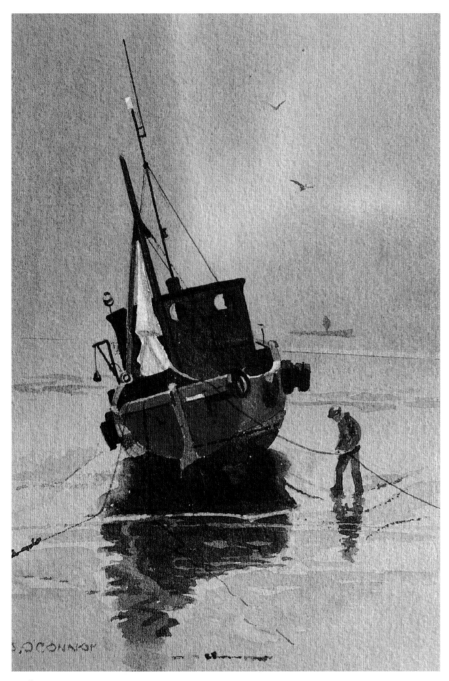

WAITING FOR THE TIDE
Robert O'Connor
Watercolor on Arches 300-lb. (640gsm)
 cold-pressed watercolor paper
11" x 7½" (28cm x 19cm)

three **(TWENTY MINUTES)** To complete the painting, O'Connor removed the masking tape from the small sail at the rear of the boat, then painted the shadowed folds. Using the same brush and color mixtures as before, he darkened several areas in the foreground to accent the wet mud, carefully leaving areas of the earlier lighter values for contrast. Finally, he painted the figure and the rope.

TOTAL TIME FOR PREPARATIONS: THIRTY MINUTES.

TOTAL TIME TO COMPLETE: ONE HOUR.

KOI POND TRIO by Tracy Reid

Learn to Play "What If?"

*i*n chapter 2 we looked at the benefits of playing "What if?" by experimenting with the same scene using different palettes. In reality, of course, whenever we create new compositions, we're playing "What if?" in many different ways. For example, what if I painted this subject larger or smaller? Would it be more dramatic or effective? What if I created a square composition or a long, skinny one? At other times, playing "What if?" is the only way to distill an amorphous subject into a concrete, paintable form. Koi ponds, the subject of Tracy Reid's demonstration, are a good example of a subject that changes constantly and, in a way, posing the "What if?" question all by itself.

"Koi ponds continually fascinate me," says Reid. "Graceful arcs in brilliant colors set off by wonderful gray greens and golds, all fractured by light and moving water." For Reid, the challenge is deciding which aspects in the unending swirl of "What if?" options might best come together as a solid artistic composition. Here are a few of her "What if's?" and a one-hour painting.

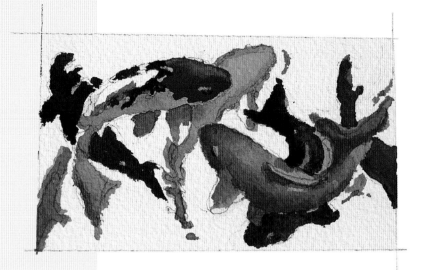

For Reid to develop pleasing compositions from her observations and photographs of koi ponds, she has to find a way to momentarily stop the action, graceful and rhythmic though it may be, long enough to create a visually satisfying arrangement of shapes and colors. Small studies such as these take about forty-five minutes each to complete and are a great tool for exploring color and form without investing the many hours required for a major painting.

KOI PATTERNS (STUDY #1)
Tracy Reid
Watercolor on Arches 300-lb. (640gsm)
 rough watercolor paper
3" x 5" (8cm x 13cm)

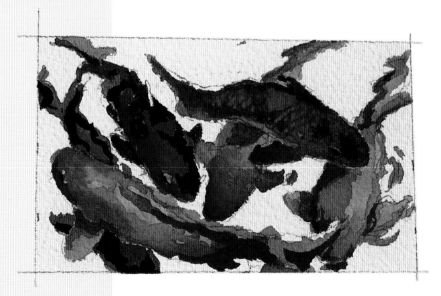

KOI PATTERNS (STUDY #2)
Tracy Reid
Watercolor on Arches 300-lb. (640gsm)
 rough watercolor paper
3" x 5" (8cm x 13cm)

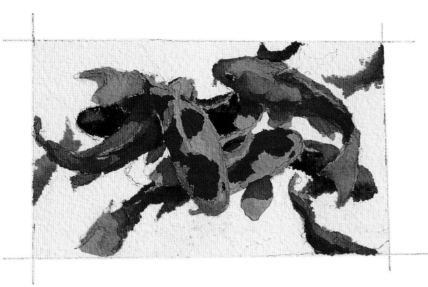

KOI PATTERNS (STUDY #3)
Tracy Reid
Watercolor on Arches 300-lb. (640gsm)
 rough watercolor paper
3" x 5" (8cm x 13cm)

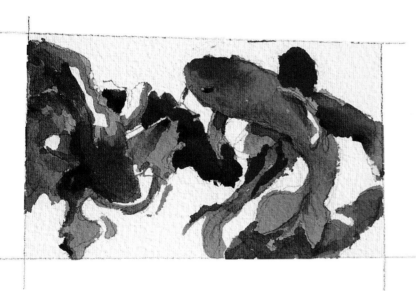

KOI PATTERNS (STUDY #4)
Tracy Reid
Watercolor on Arches 300-lb. (640gsm)
 rough watercolor paper
3" x 5" (8cm x 13cm)

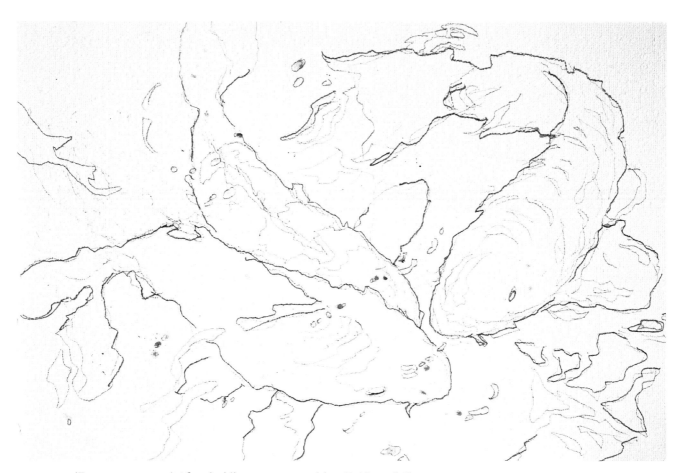

one (**Fifteen minutes**) After deciding on a composition, Reid carefully tore a 22" x 30" (56cm x 76cm) sheet of Arches 300-lb. (640gsm) rough watercolor paper to the desired size: 15" x 22½" (38cm x 57cm). To retain the appearance of deckled edges, she marked the size on the back of the sheet, then moistened along the line. After a few minutes, she tore the paper to size against the edge of a heavy steel ruler.

With the paper torn to size, she used a 2H pencil to draw a light outline of the key forms in the composition and then applied liquid masking fluid to the small "bubbles" where she wanted to preserve the white of the paper. To preserve the white in larger areas, such as the one near the center of the painting, Reid painted around them as the image progressed.

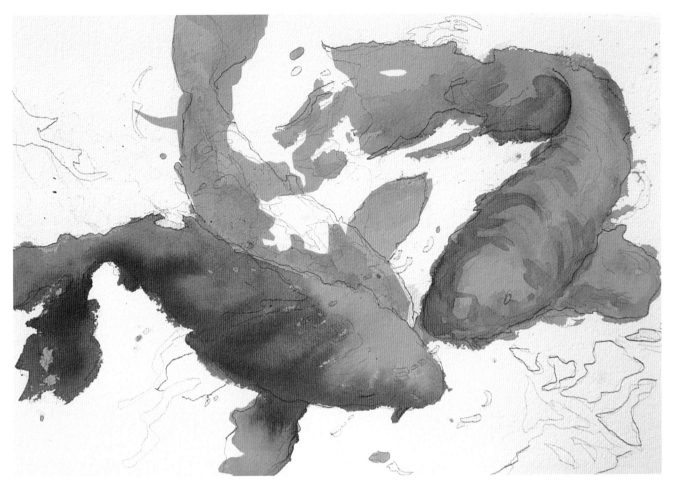

two (TWENTY MINUTES) Using an assortment of round brushes (nos. 10, 8 and 3), Reid began by applying the lightest colors to the three koi fish, starting with dilute washes of Naples Yellow and Cadmium Yellow Pale. While the colors were still wet, she applied a deeper wash of Indian Yellow to the yellow fish and to what would later become the red fish. Next, after mixing Opera (a bright pink) with Naples Yellow, she blended this mixture with the still-wet colors on the red fish as well as used it to lay down the first washes on the third (white) fish. Finally, she worked mixtures of Opera and Cobalt Blue into the same areas.

Returning with the same brushes to the yellow fish (which had dried), Reid developed its form and color further by applying mixtures of Raw Umber, Burnt Umber and Permanent Magenta in the shadow areas. On the left side, she added Cadmium Scarlet to indicate reflected color from the nearby red fish. Then, returning to the white fish (center), she added pinkish violets and Cerulean Blue along the fin edges.

Using mixtures of Cadmium Scarlet, Cadmium Red Deep, Magenta, Venetian Red, Light Red and Permanent Alizarin Crimson, Reid continued developing details and form on the red fish while carefully preserving the yellow highlights. "Red is the last color I use," she says, "because it will bleed into wet colors placed next to it even after it has dried." Finally, Reid completed the first washes by adding red spots to the white fish.

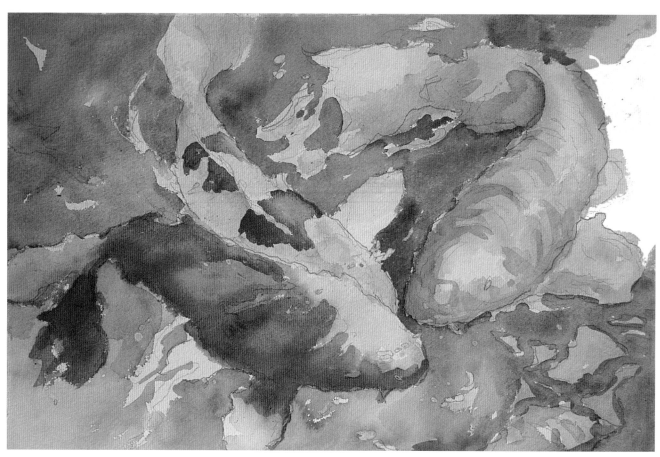

three (**Twenty minutes**) As the red fish dried, Reid began laying down initial washes in the background using a no. 14 round brush. Starting in the upper portion and working downward, she randomly moistened the paper with a spray bottle and applied varied mixtures of Indigo, Burnt Umber, Raw Sienna, plus a little Light Red in some areas to create dull green-grays.

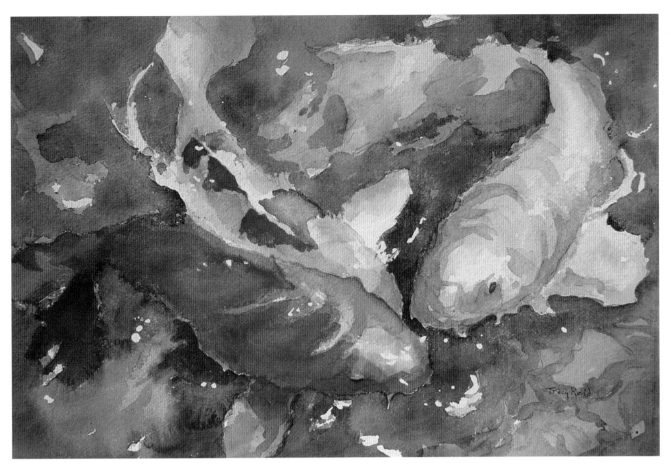

four **(Six minutes)** In the final stage, Reid used a no. 14 round brush to concentrate on what she calls the "value balancing act": adding deeper values of the same colors used in previous steps to correct value imbalances while making colors richer and more saturated in selected areas. To complete the painting, she used a no. 3 round brush to paint the eyes using mixtures of Indigo and Permanent Alizarin Crimson. When the painting was completely dry, she removed the masking fluid from the bubbles.

TOTAL TIME TO COMPLETE: ONE HOUR AND ONE MINUTE.

ST. MARTIN BEACH by Steve Rogers

Build an Idea File

t here are many ways to build useful idea files. They range from traditional methods, such as pencil or ink sketches and color studies, to photographic prints or slides and now, in the computer age, even include digital images. But regardless of the method you choose, the purpose of building an idea file is to inspire you so that whenever you sit down to paint you'll be able to recall the passion you felt on location—even if it's just for an hour.

For Steve Rogers, idea files are especially important because the focus of his current work is the Mediterranean, especially Greece and Italy. Inspiration for a year's worth of paintings must be gathered during one short visit each year. Rogers fleshes out his observations with an idea file that includes ink and color sketches and 35mm slides. "My preference," says Rogers, "is to paint on location on 18" x 24" (46cm x 61cm) sheets of Arches 300-lb. (640gsm) cold-pressed paper without any expectation of creating a 'good painting.' I'm not trying to sketch or make color notes, as these precious little gems never seem to translate into a scaled up version back in my studio. When ink or color sketches aren't feasible, Rogers uses a Minolta 700si 35mm single-lens reflex camera. "I shoot lots of film—perhaps fifty or more rolls each trip. I try to capture the special places I discover in a variety of lighting conditions.

When Rogers returns to his Florida studio, he projects his slides in a darkened room adjacent to his studio where he can view them through a small window as he paints.

Ideas come from many sources. This ink sketch is Rogers's interpretation of San Marco Square in Venice, Italy, based on slides he took while visiting there.

SAN MARCO—VENICE
Steve Rogers
Ink Sketch
18" x 24" (46cm x 61cm)

VERNAZZA, ITALY

Rogers also created this sketch from a slide he took during a recent trip to Italy. It is a good example of how one kind of idea (a 35mm slide) can be translated into a more useful and artistic conception.

VERNAZZA, ITALY
Steve Rogers
Ink sketch
21" x 18" (53cm x 46cm)

Preparations

(ONE HOUR) Working from his own slides, Rogers spent about fifteen minutes drawing this sketch of two boats on a 21" x 29" (53cm x 74cm) sheet of Fabriano Uno 300-lb. (640gsm) rough watercolor paper using a mechanical pencil with HB lead. After soaking the sketch in a bathtub for about thirty minutes to remove excess graphite and break the surface tension so that it would absorb water more evenly, Rogers stretched the soaked paper on a varnished piece of ⅜" (1cm) marine plywood using staples placed at 1" (2cm) intervals. When the paper had dried, he covered the staples with masking tape so they would not stain the paper as he applied later washes.

Painting

one (ELEVEN MINUTES) Using a no. 12 Winsor & Newton Series 7 round sable brush and various mixtures from each of his "standard" palette of colors (see sidebar), Rogers laid in the background. This allowed him to quickly establish the value range from darkest dark to lightest light (the white of the paper). In these first washes, he also established the range of colors he'd use as well as their brilliance (hue or saturation).

The background (left), for example, was painted directly with palette reds and oranges, mixed or modified directly on the paper. The right side was flooded with various palette yellows and oranges and modified with palette greens and blues.

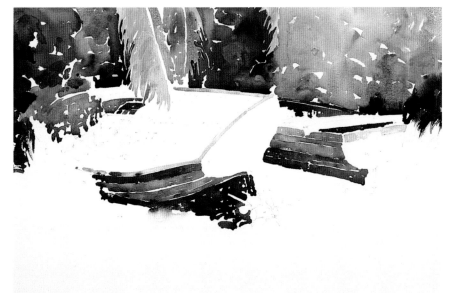

two (FOURTEEN MINUTES) Rogers began developing the shadow sides of each boat using a no. 9 Winsor & Newton Series 7 round sable brush. To paint these areas, he used a range of palette blues modified on the paper with Permanent Rose and Yellow Ochre.

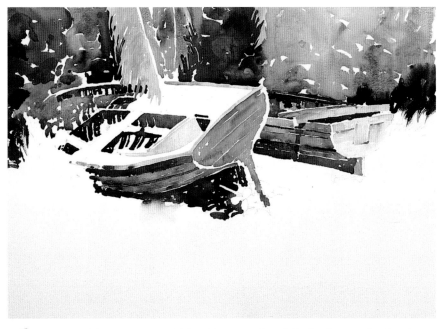

three (EIGHT MINUTES) Next, Rogers painted the background colors into the shadows falling on the boats so that the boats would not appear "cut out" and pasted onto the background. By painting the effects of light and shadow rather than painting the minutiae of individual boards, propellers, rudders and so on, Rogers avoided a jumble of distracting detail and kept the image unified. These areas were painted using a no. 9 Winsor & Newton Series 7 round sable brush and a full complement of palette blues, modified with Scarlet Lake and other warm palette colors.

Rogers's Palette

Burnt Sienna
Raw Sienna
Yellow Ochre
Cobalt Turquoise
Cobalt Green
Aureolin
Cadmium Yellow Pale
Cadmium Orange
New Gamboge
Cadmium Scarlet
Scarlet Lake
Rose Doré
Brown Madder
Permanent Rose
Permanent Magenta
French Ultramarine Blue
Cobalt Blue
Cerulean Blue
Manganese Blue
Prussian Blue

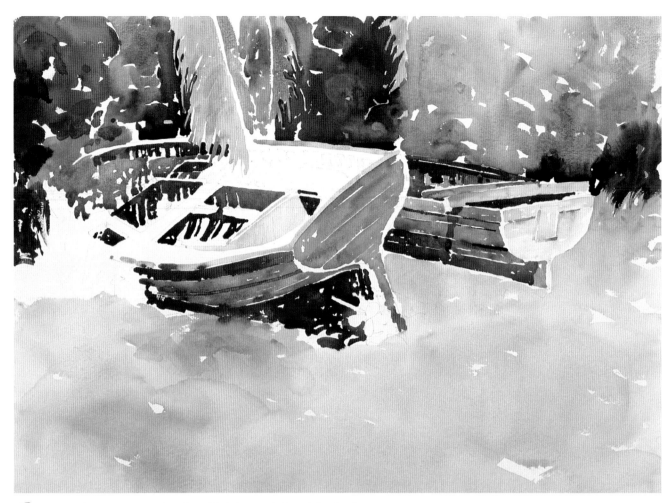

four (NINE MINUTES) As he added the sandy beach in the foreground using a 1½-inch (38mm) hake brush, Rogers paid special attention to edges throughout the image. "I keep some edges hard," he says, "to strengthen contrast; others are soft to bridge two areas. Still others remain rough or broken. Throughout, I strive for variety and a dominance of edge quality."

Rogers used Cadmium Yellow Pale, New Gamboge and Yellow Ochre to paint the beach, then moderated the resulting color with Cerulean Blue and Cobalt Blue. Finally, he added several touches of his palette reds for balance and to retain an overall feeling of warmth.

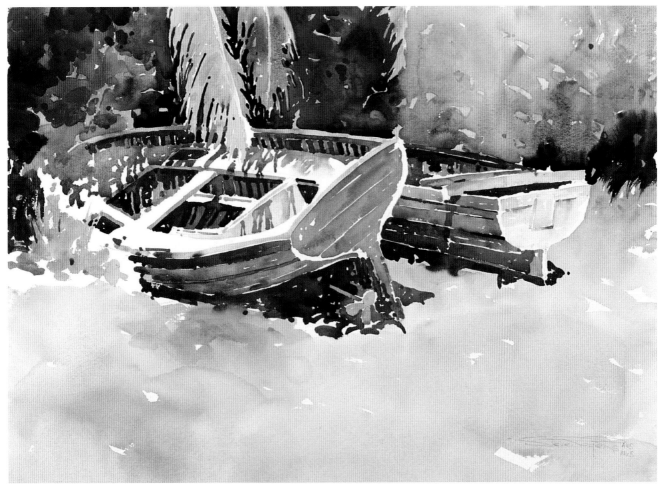

five (**Eighteen minutes**) According to Rogers, "I don't use smaller brushes even for detail or in very small areas. This helps me paint detail without being overly precise."

To complete the painting, Rogers used a no. 9 Winsor & Newton Series 7 round sable brush to add finishing touches: a suggestion of a propeller, a bush on the left and shadows beneath both boats. (Note that a portion of the line separating the keel of the rear boat from its cast shadow is pure Manganese Blue; the rest of that line is pure Cadmium Orange.)

Total time for preparations: one hour.

Total time to complete: one hour.

ST. MARTIN BEACH
Steve Rogers
Watercolor
21" x 29" (53cm x 74cm)

Create Great Compositions Quickly

*a*ll paintings begin as vague concepts and then take concrete form when an idea becomes a composition: a pleasing arrangement of forms within a defined space such as a square or a rectangle. Knowing this, it's obvious that anything that moves you more quickly from idea to compositional drawing helps you spend more time painting and less time pondering and procrastinating. As we've already seen, there are many mechanical aids for developing compositions quickly (see chapter 2) but ultimately the process of composition is highly personal and very intuitive. If your subject or temperament seems more suited to an intuitive approach, you might find that you respond to color, for example. In that case, you might lay down seemingly random washes of several colors that interact in a pleasing or exciting way and then see what forms or subjects suggest themselves for further development.

Many artists also find that music stimulates their creative processes. For David Maddern, the connection between music and painting is more direct. "My formal training is in applied music," says Maddern. "I try to make aural statements in visual terms: Tonal balance in polarity, chromaticism, compositional structure and thematic transparency are important to me." Here's how he applies these ideas to a one-hour painting.

one **(FIFTEEN MINUTES)** Working on a 22" x 30" (56cm x 76cm) sheet of Arches 300-lb. (640gsm) cold-pressed watercolor paper, Maddern dampened the surface and established a "rhythm" using three curved pencil lines. Next, using a 2½-inch (64mm) flat brush, he applied neutral mixtures of Viridian and Permanent Rose (complements) to the upper and lower portions of the image before adding Aureolin toward the center. Before the paper dried completely, he misted the upper section with clean water to encourage the granulating characteristic of Viridian and to promote a slight separation of the complements (visible as a faint violet tint at the lower edge of the top curve).

two **(FIFTEEN MINUTES)** With the paper dry, Maddern quickly drew the flower form, then added color with various chisel brushes using Aureolin alone and in mixtures with Permanent Rose or Viridian. The top petal (center) was scrubbed out with an old oil painting brush in two places to define its shape against the darker background. This was possible because all the colors used to this point were non-staining. Finally, the lower petals were established using mixtures of Viridian and Permanent Rose and a ½-inch (13mm) chisel brush.

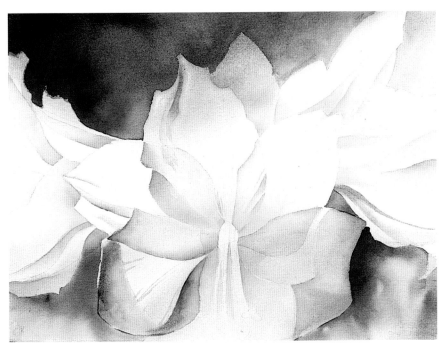

three **(FIFTEEN MINUTES)** Working with the chisel brushes and the paper still wet, Maddern used a second set of complements (Alizarin Crimson and Winsor Green) to further define the negative space around the upper petals. At the same time, he established several additional petals in the upper and lower portions of the image using the same technique, brushes and colors. Next, he strengthened the yellow on the leftmost blossom with a wash of Aureolin. He concluded this phase by adding warm shadows to various areas, including the rightmost blossom, using mixtures of Aureolin and Permanent Rose.

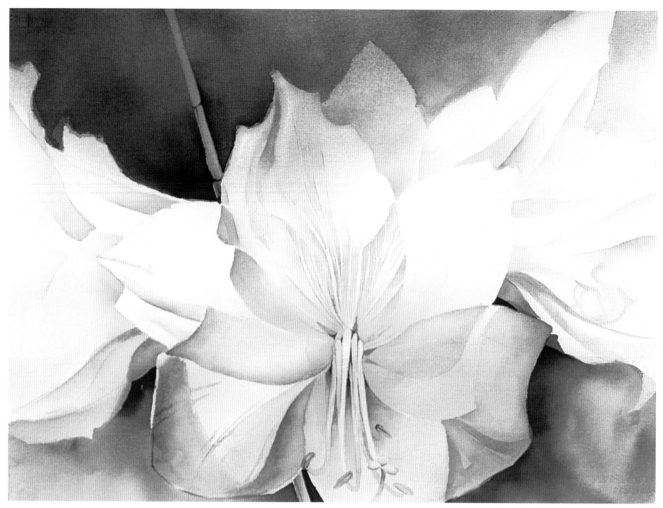

four (FIFTEEN MINUTES) Next, Maddern drew the outline where the bamboo stake was to appear and, after carefully wetting the area, used a 1-inch (25mm) chisel brush and paper towels to remove the color applied in previous steps. After adding details to the bamboo stake with a no. 4 round brush, he used the same chisel brush as before to apply darker mixtures of Alizarin Crimson and Winsor Green to either side of the stake and next to the bottom petals. To complete the painting, he "found" the stamens by painting the negative shapes around them with a no. 4 round brush using mixtures of Aureolin and Viridian.

TOTAL TIME TO COMPLETE: ONE HOUR

WHITE AMARYLLIS
David Maddern
Watercolor on Arches 300-lb. (640gsm)
 cold-pressed watercolor paper
22" x 30" (56cm x 76cm)

Use Rapid Sketching to Play "What If?"

*d*espite our outward eagerness to paint, we often find many ways to unconsciously delay the terrors of confronting that gaping expanse of blank paper. When you have only sixty minutes, every minute counts. Rapid sketching is a great way to get the creative juices flowing and, in the process, quickly explore a variety of "What if?" scenarios.

Gustavo Castillo uses rapid sketching routinely, and he uses those sketches to create a whole series of related images. "Every time I come into my studio," he says, "I'm excited because I don't know what is going to happen. I tend to work in a series because every time I work on a squash or a pear, I gain information about the subject and it becomes easier to understand their anatomy and general characteristics."

Castillo often works from life, arranging his subjects and then walking around his setup, looking at the objects from different angles as well as from above and below eye level. "I may sketch the elements together or separately," he says, "and usually as I do that, several ideas for paintings begin to appear. As I sketch, I keep in mind that my work has to do with the size of the elements and that all I need are simple lines and a sense of light. The small details can be worked out later on the watercolor paper."

This spontaneous approach to sketching is a wonderful antidote for the urge to procrastinate. Castillo's simple, rapid sketches neatly sidestep the delays and vacillation that often result when artists allow themselves to become consumed with unnecessary details and refinements rather than concentrating on essential ideas and inspirations.

To explore the different shapes the same fruits had to offer, Castillo sketched them separately and together and from a variety of angles and elevations. "Working very close to them, sometimes through a mat window, they stop being just fruit," he says, "and become an almost abstract landscape."

Here's another "solo" view of one of Castillo's potential subjects.

In all, Castillo made nine quick sketches while preparing to paint *Ponderossa Lemons* (see chapter 2 for additional sketches). Of the sketches, this one seemed to hold the most promise for a one-hour painting.

one **(THREE MINUTES)** Although Castillo was happy with sketch no. 9, he still made changes as he lightly drew the bare outlines on a piece of 13" x 9½" (33cm x 24cm) Arches 300-lb. (640gsm) cold-pressed watercolor paper. When the drawing was complete, he masked out the stem using Winsor & Newton colorless masking fluid, taking care to cover the pencil lines so they could be erased easily before the stem was painted in a later step.

Castillo uses a palette with three large, deep wells in the center and his pure colors arranged in smaller wells around the palette's perimeter. In one of the wells, he premixes a yellow "soup" using Winsor Yellow with a little Raw Sienna. In another well, he premixes a green "soup" using Cerulean Blue, Raw Sienna and Winsor Yellow. The third well is reserved for mixing other colors with either of the two main mixtures to make them warmer or cooler, darker or lighter.

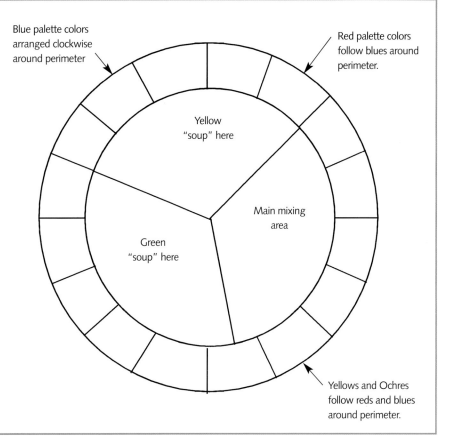

Blue palette colors arranged clockwise around perimeter

Red palette colors follow blues around perimeter.

Yellow "soup" here

Main mixing area

Green "soup" here

Yellows and Ochres follow reds and blues around perimeter.

Yellow "Soup"

This swatch shows how the basic yellow mixture of Winsor Yellow with Raw Sienna looks when first applied (left) and how it darkens and changes with successive glazes (middle and right portions).

Green "Soup"

This swatch shows how Castillo's second premixed color, a green hue, looks when applied with more water (left) or less water (right).

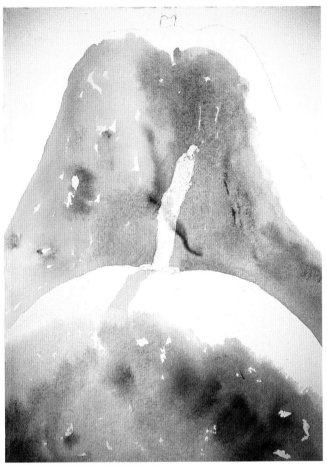

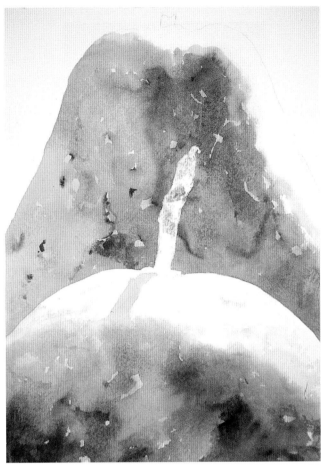

two (Twelve minutes)
First layer. Castillo worked directly on the paper without stretching or taping it down. Using a no. 6 red sable round brush, he applied washes of his yellow mixture over all but the sunlit portions of both fruits. As he applied the wash, he periodically touched his brush lightly on various colors (Brown Madder, Cobalt Blue and Winsor Red) from around the rim of his palette to add color variations and texture to the basic yellow wash. While the paper was still wet, he used a second, clean no. 6 red sable round brush to apply his green "soup" to the bottom of the foreground fruit and to the right side of the background fruit. He used a hair dryer to speed drying prior to the applying the next layer.

three (Twelve minutes)
Second layer. Before proceeding, Castillo erased any remaining portions of his pencil drawing that were no longer needed. Then, using the same brushes with denser mixtures of color to avoid lifting the previous washes, Castillo strengthened the basic colors with additional washes. To complete the second layer, he used a dry-brush technique and the same brushes and colors as before to add more details to the fruit skins.

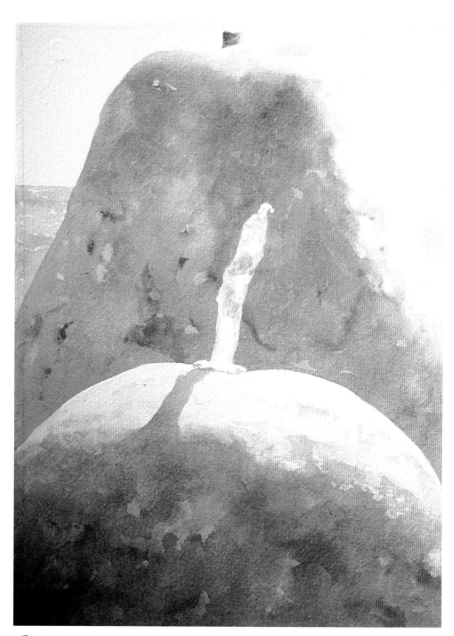

four **(Twelve minutes)**
Third layer. Castillo heightened contrasts between the two fruits with additional washes, making the background fruit warmer in the process. Working with the basic washes described earlier, he touched his brush to Cerulean Blue and Cobalt Blue to darken and cool the foreground fruit and its stem shadow. Next, he painted the stem of the background fruit, keeping it short to avoid calling attention to it and to allow a bit of sky to show above it for openness. To complete the third layer, Castillo painted the distant water using mixtures of Cobalt Blue, Alizarin Crimson and a touch of Naples Yellow to make it creamier. Small areas of the paper were left unpainted to suggest movement in the distant water.

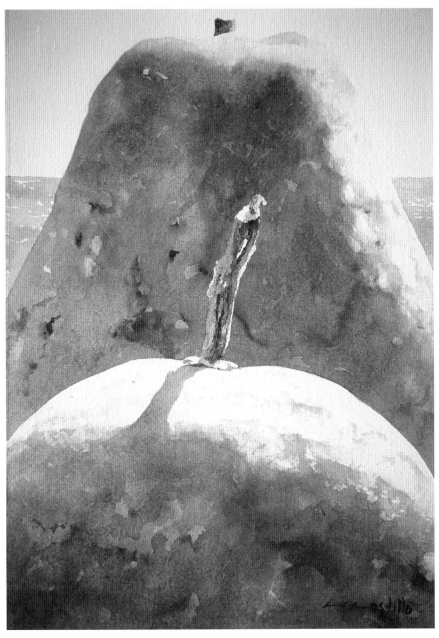

PONDEROSSA LEMONS
Gustavo Castillo
Watercolor on Arches 300-lb. (640gsm)
cold-pressed watercolor paper
13" x 9½" (33cm x 24cm)

five **(Fifteen minutes)**
Fourth Layer. To complete the painting, Castillo added more pigment to his yellow "soup" and leaned it heavily toward Winsor Yellow to intensify the overall brightness of the colors. Working in the same manner as before and with the same colors and a no. 6 red sable round brush, he strengthened contrasts throughout the image. After adding more details to the skin, he worked the edges with clean water using wet-in-wet and dry-brush techniques to make the edges varied and interesting. Finally, he removed the masking from the stem and erased the pencil lines before painting it in three layers using mixtures of Cobalt Blue, Brown Madder and Alizarin Crimson.

Total time to complete: Fifty-four minutes.

Masking With Liquid Masking Fluid and Tape

*i*n the "Quick and Easy Special Effects" section (chapter 2), we saw that masking tape and masking fluid could be used for similar purposes. There is indeed some overlap in the two methods of preserving the white of your paper when applying washes or other painting techniques. At first glance, the two procedures might seem redundant, but each has unique uses.

In general, use masking tape when you want to cover large areas with relatively well-defined shapes in a hurry. As you saw in chapter 2, masking tape works equally well for small, irregular shapes as long as they are also reasonably well defined.

Liquid masking fluid is versatile as well, but its fortes are fine lines and intricate shapes. What you may not realize is how well the two masking techniques work together. In *Chinese Bottle*, I used tape to preserve the whites and the straight edge of the shelf. At the same time, I used liquid masking fluid to preserve the whites for the shape of the Chinese bottle. Needless to say, I could have used the tape for this as well, but I'm a klutz with a knife and would surely have inflicted more damage to myself than to the paper. Anyway, let's take a look at the role masking (as well as other quick and easy special effects) played in Chinese Bottle.

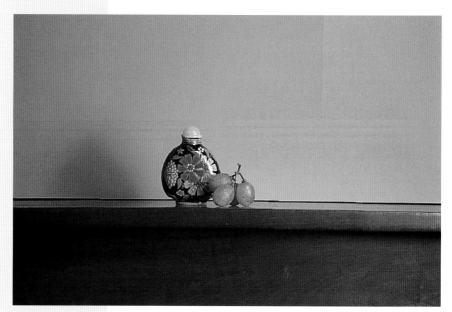

I collect various "props" as I travel and then experiment with different setups to see what satisfies my compositional sense. This is a classic triangle composition, and I felt that it looked quite promising. To verify my thoughts, I scanned the slide into my image-editing software (Adobe Photoshop) and tried cropping the reference in various proportions using rectangular and square formats. In the end, I chose a square format as the most effective.

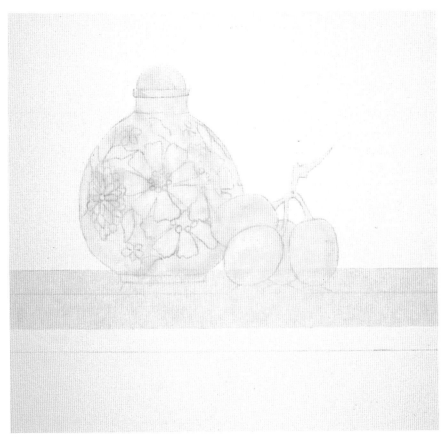

Preparation

(THIRTY MINUTES) To get the most out of my time, I projected the portion of the reference I'd selected onto a 6" x 6" (15cm x 15cm) piece of 140-lb. (300gsm) Arches cold-pressed watercolor paper and drew the outlines of all major and minor elements with a 5H pencil. After allowing for a ¼" (6mm) margin all around for taping the paper down with masking tape, I was left with a 5½" (14cm) square image (which was my intention). After correcting the drawing with a T-square and French curve drafting template, I taped the paper down on all sides with masking tape. Next, I aligned another strip of masking tape along the top front edge of the shelf to preserve the whites and establish a clean straight edge below the background.

Finally, I soaped an old no. 4 round brush and used it to apply two coats of liquid masking fluid over the shape of the bottle, making certain that the masking fluid overlapped the tape where the two touched.

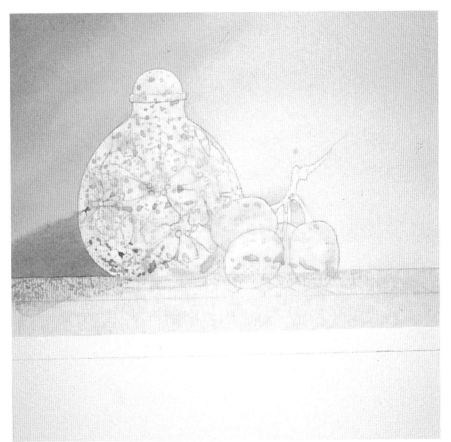

Painting

one **(FIVE MINUTES)** After prewetting the paper with a 1-inch (25mm) flat brush and clean water, I used various mixtures of New Gamboge, Alizarin Crimson and Burnt Umber to apply a variegated wash that graded from light on the right to darker on the left. As the sheen just went off the paper, I added the cast shadow of the bottle using the same brush and basic color mixture darkened with Warm Sepia.

two **(Ten minutes)** After drying the background wash with a hair dryer to speed things along, I removed the masking tape but left the dried masking fluid in place. I then used liquid masking fluid to carefully remask the now-exposed lower portions of the bottle and grapes (which had been covered by the tape) so that I could paint the top of the shelf without interruption.

After drying the masking fluid with a hair dryer, I painted the area from the rear of the shelf top all the way to the bottom of the image using a ½-inch (13mm) flat brush and mixtures of Burnt Sienna, French Ultramarine Blue and New Gamboge. After drying again with a hair dryer, I used a 1-inch (25mm) flat brush to apply a wash of the same mixture darkened with more Burnt Sienna, from the upper edge of the shelf face to the bottom of the image. Finally, I used a no. 4 round brush to darken the bottle's cast shadow further with Warm Sepia.

three **(Five minutes)** Next, with a no. 4 round brush and mixtures of Burnt Sienna and Warm Sepia, I added the bottle's cast shadow on the shelf top and a fine shadow beneath its base. Then, with a 1-inch (25mm) flat brush and a dark wash of Charcoal, Burnt Sienna and Alizarin Crimson, I painted the shadow below the shelf. The shelf face seemed anemic, so I brightened it with a wash of Cadmium Orange and New Gamboge, which I applied with a ½-inch (13mm) flat brush.

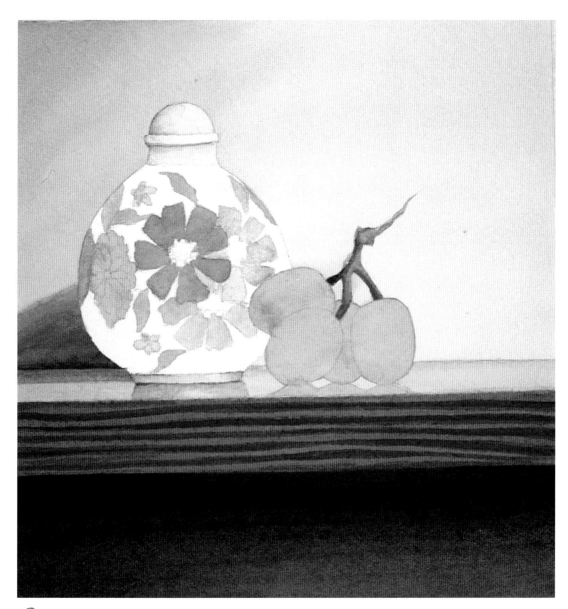

four (**Fifteen minutes**) Using masking tape, I lifted an edge of the dried masking fluid covering the bottle then peeled it away. Then, working swiftly, I used a no. 4 round brush and various colors from my palette to paint the leaves and flowers on the bottle. Use your own judgment in situations like this. Feel free to interpret; it'll make your job easier and faster.

Next, I used a no. 4 round brush and various mixtures of Cadmium Yellow Pale, Sap Green and Burnt Umber to paint the shapes and shading of the grapes. For the stem, I used the same brush and various mixtures of Sap Green, Sepia and Charcoal. Finally, I painted the wood grain on the front edge of the shelf with the same brush and dark mixtures of Burnt Sienna and French Ultramarine Blue.

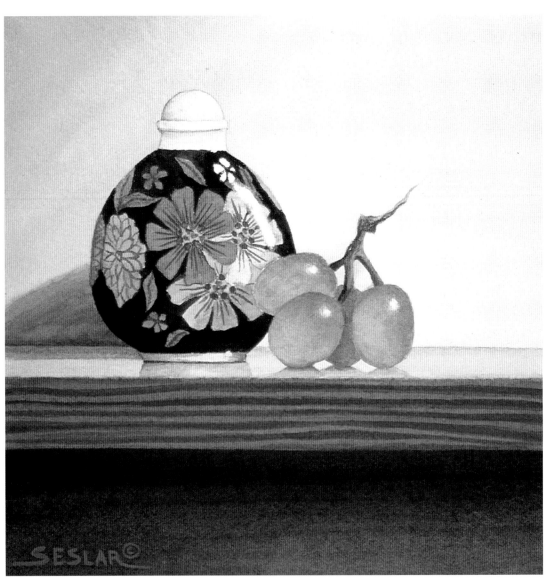

five **(FIFTEEN MINUTES)** Continuing to work swiftly with a no. 4 round brush, I applied Charcoal to the bottle, carefully painting around the decorations I'd painted in the previous step. Next, I added highlights to the grapes and bottle using Permanent White gouache (opaque watercolor). I could have preserved the white of the paper for the highlights but I'm not a purist, so I used gouache because it is easier and faster. To complete the painting, I painted the finest details (lines on the petals, etc.) using a no. 0 round brush and mixtures of Burnt Sienna and French Ultramarine Blue.

Even though this is a small image, I had to work with speed and confidence to complete it in one hour. If you are unfamiliar with this subject, it may take you longer.

TOTAL TIME FOR PREPARATIONS: APPROXIMATELY THIRTY MINUTES.

TOTAL TIME TO COMPLETE: ONE HOUR.

CHINESE BOTTLE
Patrick Seslar
Watercolor on Arches 140-lb. (300gsm)
 cold-pressed watercolor paper
5½" x 5½" (14cm x 14cm)

How Many Colors and Brushes Are Enough?

i am an advocate of keeping the number of colors and brushes as small as practical and becoming intimately familiar with the working characteristics of each one. Still, watercolor is a highly personal medium and every artist has his or her own views on this subject. A smaller variety of colors and brushes can mean less time spent debating which color or brush to use, but in the end, the number of colors and brushes you work with may be more a reflection of your own temperament than of any "one size fits all" rule. Here, for example, are Luke Buck's thoughts on what should occupy your palette.

"Watercolor offers a great advantage over other mediums," says Buck. "You can keep your palette full and not waste any pigment: If it dries out, just add water and, in most instances, the paints will last until needed."

"I keep twenty-four to twenty-six colors on my palette at all times. I seldom use them all in one painting, but if I need them, they are there waiting and I don't have to waste time searching for additional tubes of color. If I haven't been using a color, I sometimes remove it from my palette or add a new color that looks more promising."

That said, let's take a look at *Cat Nap*, in which Buck used ten of the colors on his palette and three brushes to complete the painting.

one **(TWENTY-FIVE MINUTES)** Using a utility knife, Buck cut an 8½" x 11" (22cm x 28cm) piece of Crescent cold-pressed watercolor board from a larger panel, then carefully drew his subject with an HB pencil. "In painting wildlife or any identifiable object," he says, "the initial drawing is very important. It's much easier to start correctly than to correct mistakes later on. I nearly always include more detail than seems necessary because a detailed sketch helps me determine where to put shading and form as I progress with the painting."

two **(FIVE MINUTES)** After using a ¾-inch (19mm) flat brush and clean water to wet the entire panel, Buck mopped up the excess with paper towels. He then used a no. 4 Winsor & Newton Series 7 round brush and a wet-in-wet technique to model the shading throughout the image using a dense mixture of Zinc White (gouache), Cerulean Blue and Sepia. "Most beginning watercolorists make the mistake of using too much water in their mixtures," says Buck. "By keeping my mixture mostly pigment with very little water, I had a very controllable mixture that made it much easier to lay in form throughout the image."

three **(EIGHT MINUTES)** Buck next used various mixtures of Raw Sienna, Sepia, Burnt Sienna and Zinc White (gouache) to continue modeling the form in the same manner as in the previous step and with the same brush. "Again," says Buck, "my mixtures were mostly pigment with very little water. As an alternative, you could brush the paint on, quickly soften the edges with a clean, wet brush and then return to add detail using dry-brush techniques."

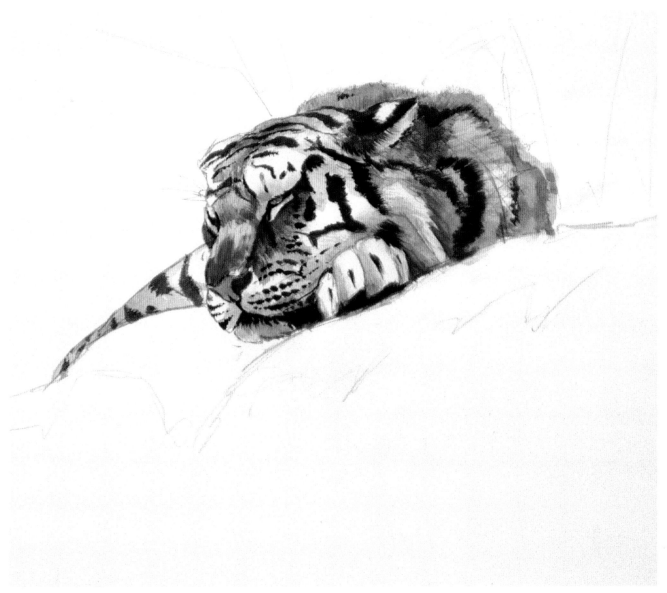

four (FOURTEEN MINUTES) Next, Buck added the darker stripes and shadows. Continuing to work with a no. 4 round brush, he used a dense mixture of Sepia modified with either Cerulean Blue (to soften the tone) or Ultramarine Blue (to darken the tone). When those areas were complete, he used the same brush to add color to the eye with Golden Yellow (gouache) and warmth to the nose with Cadmium Red Light. "Take your time," says Buck, "this is the step that pulls it all together!"

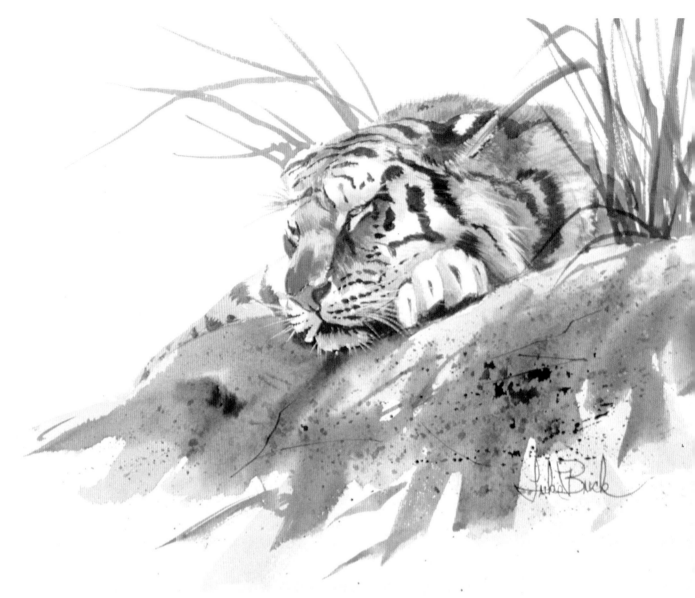

five (EIGHT MINUTES) With mixtures of Sepia and Hooker's Green Light and a no. 4 round brush, Buck painted the background grasses with quick, spontaneous strokes. Then, with the ¾-inch (19mm) flat brush and mixtures of Sepia, Zinc White (gouache), Cerulean Blue and a touch of Winsor Violet, he painted and modeled the large foreground rocks under the tiger. Next, he covered everything but the foreground rocks with tracing paper, then used the rock color mixture and a ¾-inch (19mm) flat brush to spatter texture onto the rock's surface. To complete the painting, Buck used a no. 3 round liner brush and Zinc White (gouache) to add the tiger's eyebrows and whiskers.

TOTAL TIME TO COMPLETE: ONE HOUR.

CAT NAP
Luke Buck
Watercolor on Crescent cold-pressed watercolor board
8½" x 11" (22cm x 28cm)

Luke Buck

"I'm not what you'd call a 'purist,'" says Luke Buck, "most of my colors are transparent, but I also use gouache. In the course of a typical painting, I model the forms and details of my subjects by working both transparently and opaquely, using the medium more like acrylic than traditional watercolor."

Following in his artist-father's footsteps, Buck became a professional artist in 1959. Since then, he has gained extensive experience working in many mediums and has received numerous awards and honors. Although widely known for his watercolors of wildlife, Buck says his favorite subject is the vanishing American landscape.

Buck maintains his studio at the lakefront home in southern Indiana where he and his wife, Coleen, reside.

CONTACT INFORMATION
Luke Buck
P.O. Box 216
Nineveh, IN 46164

BUCK'S PUBLISHER
Mill Pond Press
310 Center Court
Venice, FL 34292-3500
(800) 535-0331

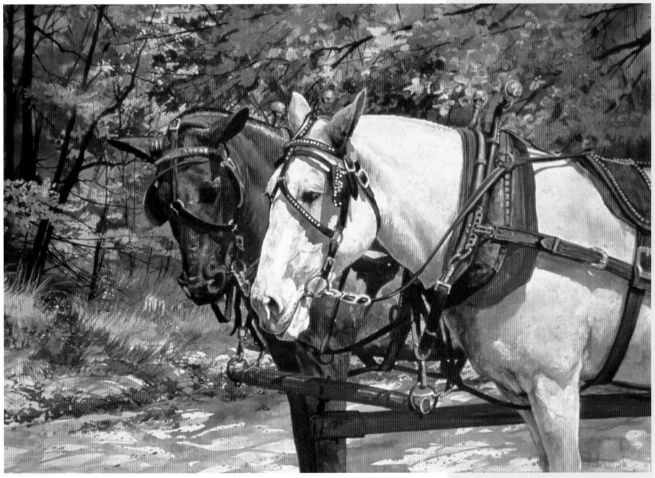

JAKE AND POLLY
Luke Buck
Watercolor
30" x 40" (76cm x 102cm)

Gustavo Castillo

"I am a realist," says Gustavo Castillo, "but I'm also very concerned with the abstract elements of my paintings ... you see, during the painting process form and color play together for me creating an abstraction in every scene. In the final analysis, form and color redefine the subject."

Born in Manizales, Colombia, Castillo originally trained as a mechanical engineer and a commercial pilot. When jobs became scarce, he decided to take up painting. In 1986, Castillo moved to the United States where he continued studying the works of other artists, including Andrew Wyeth and Winslow Homer.

Since coming to the United States, Castillo has won numerous awards in juried art festivals across the country. His work is represented by the LeMoyne Art Foundation (Tallahassee, Florida). Castillo and his wife, Carmen Lagos, live and work in Jupiter, Florida.

CONTACT INFORMATION
Web site:
www.castillolagosstudio.com

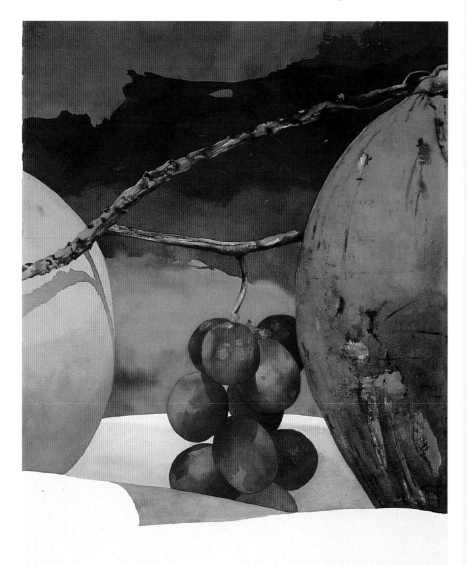

SUPPORT #2
Gustavo Castillo
Watercolor
30" x 22" (76cm x 56cm)

Pamela Jo Ellis

"I choose scenes to paint because they're intensely familiar," says Pamela Jo Ellis, "scenes I pass every day in town and near my home. I paint winter scenes because I love the crisp harsh beauty of the images and the challenge to living that cold represents. I paint my children because they are so beautiful ... gifts from God ... and the way I feel about my children represents every mother's feelings for every child."

Ellis received her degree in Art History (with a concentration in Fine Art) from Colby College in Waterville, Maine, in 1981. Her realist style draws upon influences such as the depth found in English landscapes, the immediacy of Homer and the simplicity of traditional Japanese paintings. "As a painter of 'small works,' my paintings tend to stand out at art shows," says Ellis. "I don't market myself completely as a miniaturist, but if you're short on time and enjoy working small, minis are worth trying."

Ellis's work is represented by five galleries in Maine: Birdsnest Gallery (Bar Harbor), Gallery 7 (Portland), Christmas Classics and Collectibles (Rangeley), Birds of a Feather Gallery (Rangeley) and The Gallery at Stony Batter Station (Oquossoc). Ellis lives with her children, Bethany and Connor, on the east shore of Rangeley Lake in the western mountains of Maine.

CONTACT INFORMATION
Pamela Jo Ellis
P.O. Box 227
Rangeley, ME 04970
(207) 864-2556

E-mail: pjellis@rangeley.org
Web site: www.pamelajoellis.com

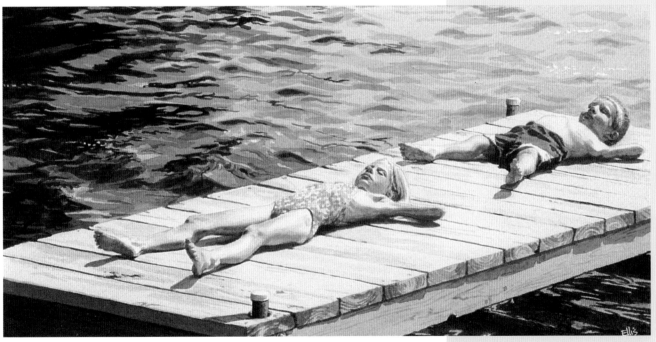

BASKING
Pamela Jo Ellis
Watercolor
5" x 10" (13cm x 25cm)

Carmen Lagos

"My training as an architect provides me with a strong sense of design," says Lagos. "I am constantly redesigning elements of nature so that my paintings become original 'rearrangements.' I never copy nature—I orchestrate it."

Born in Santiago, Chile, Lagos moved to Barranquilla, Colombia, at the age of thirteen. After high school, she graduated from the Universidad Autonoma del Caribe where she received a degree in architecture. Lagos worked as a Projects Designer for the Terpel Oil Company before moving to the United States in 1988 to pursue her interest in art.

Lagos has won numerous awards at juried art festivals and is well known for her watercolors and ceramic creations. Her work is represented by the LeMoyne Art Foundation (Tallahassee, Florida). Lagos and her husband, Gustavo Castillo, live and work in Jupiter, Florida.

CONTACT INFORMATION
Web site:
www.castillolagosstudio.com

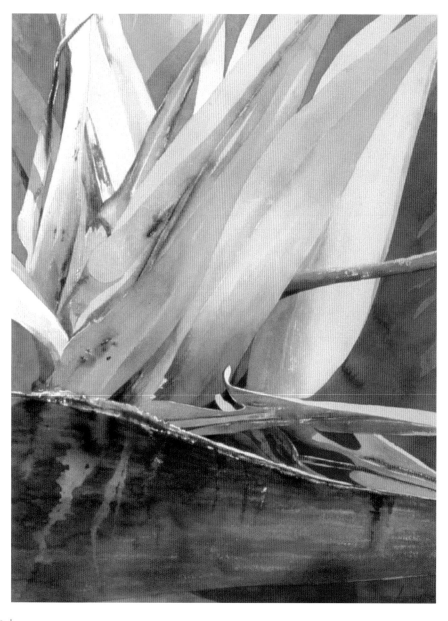

SAILING #3
Carmen Lagos
Watercolor
30" x 22" (76cm x 56cm)

David Maddern

"The formal structures of music," says David Maddern, "are relative to those of painting, and color is idiomatic to both. Further, I am influenced by the fluidity of impressionism in music and painting and by the symbolist poets. It seemed then a natural progression to the medium of transparent watercolor with its inherent unpredictability and spontaneity, for while watercolor may be guided, it ultimately enjoys a life of its own."

Maddern, who holds degrees in applied music, is a signature member of the Florida Watercolor Society, Gold Coast Watercolor Society, Louisiana Watercolor Society, Western Colorado Watercolor Society and the Watercolor West Watercolor Society. His paintings are included in *The Best of Watercolor*, *The Best of Watercolor: Flowers*; *The Best of Watercolor: Painting Color*; *Floral Inspirations*; and *The Best of Watercolors,* Vol. III (all by Rockport Publishers. Maddern is listed in *Who's Who in America*. Maddern lives and works in Miami, Florida, where he teaches beginning and advanced watercolor classes at Fairchild Gardens.

CONTACT INFORMATION
David Maddern
6492 S.W. 22 St.
Miami, FL 33155-1945
Phone/fax (305) 264-1708

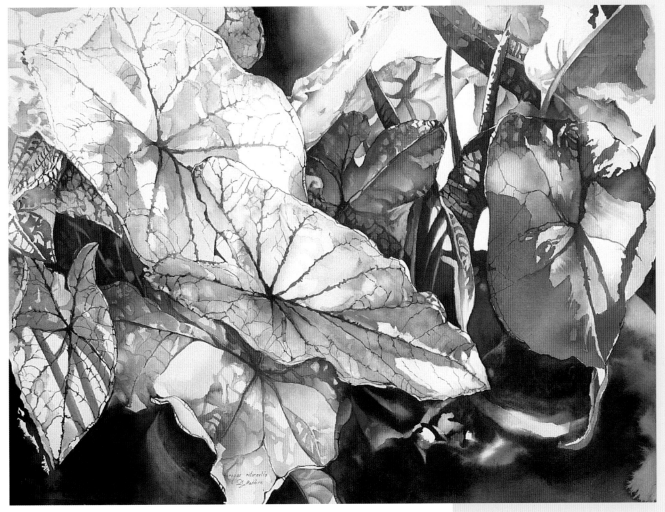

BAROQUE RITORNELLO
David Maddern
Watercolor
22" x 30" (56cm x 76cm)

Robert O'Connor

"I always drew well as a child and always felt I wanted to do something with art," says Robert O'Connor, "but life had other things in mind." In 1979, after spending thirty-one years working for the New York Central Railroad, then managing a retail sporting goods business and, finally, building and marketing homes, O'Connor and his wife, Diane decided to do things they'd always wanted to do: travel and pursue his artistic inclinations.

Since then, O'Connor has painted year-round, including the six months each year that he and his wife travel in their recreational vehicle. In addition to exhibiting at numerous galleries, O'Connor has participated in many juried arts festivals. He has won over fifty awards, including many best of show and first place awards. His work is represented by The Village Artisans Gallery (Boiling Springs, Pennsylvania), and he is a member of the Salmagundi Club (New York City), the International Society of Marine Painters, Whiskey Painters of America and the Art Association of Harrisburg (Pennsylvania).

O'Connor maintains a home and studio in Boiling Springs, Pennsylvania, where he and his wife live when they aren't roaming the country in their travel trailer/art studio on wheels.

CONTACT INFORMATION
Robert O'Connor
659 Spring Lane
Boiling Springs, PA 17007

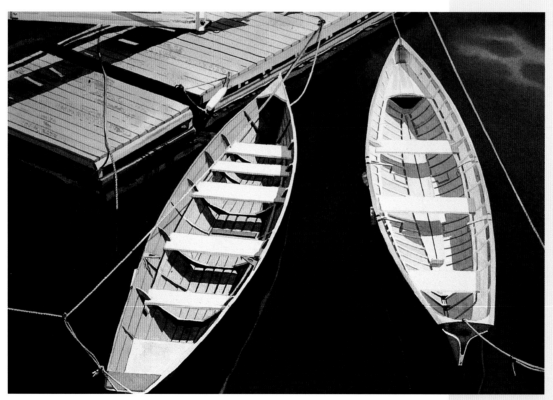

TIED FOR THE DAY
Robert O'Connor
Watercolor
24" x 38" (61cm x 97cm)

Tracy Reid

"Transparent watercolor presents unique challenges," says Tracy Reid. "Among them is predicting the effect of layering one pigment upon another and the difficulty of changing a color once it's laid down. I use tube pigments and keep about thirty-one colors on my palette. I prefer large formats—30" x 40" (76cm x 102cm) or larger—as they provide the impact I'm after. Koi fish are one of my favorite subjects because they present an ever-changing combination of the abstract and the representational."

Born in San Diego, California, Reid studied at Pierce College in California and with nationally recognized watercolorists Gerald Brommer, Tom Nicholas, Judi Betts, Maxine Masterfield, George Labadie and others. Her work has received numerous awards and recognitions and is found in many corporate collections including those of Kaiser Permanente Hospitals, Neutragena (Paris), Toyota and the Hyatt Regency Hotel. Reid's work is represented by C.L. Clark Galleries (Bakersfield, California) and the Charleston Gallery (Naples, Florida).

CONTACT INFORMATION
None

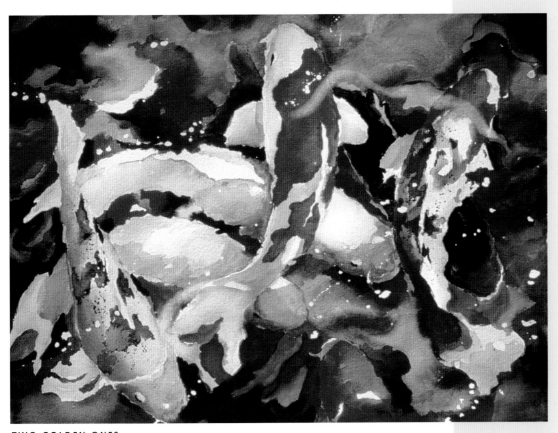

TWO GOLDEN ONES
Tracy Reid
Watercolor
22" x 30" (56cm x 76cm)

Janet Rogers

"Watercolor is a fascinating medium," says Janet Rogers. "Its unique fluid quality allows for an immediate expression and response. Most of my subjects are people and flowers—their 'aliveness' is my inspiration. My goal is to let the watercolor reveal this by allowing it to have its own life."

Rogers is a signature member of the Florida Watercolor Society and a member with excellence of the South Carolina Watercolor Society. She has won numerous awards at the Florida Watercolor Society and at juried art festivals. Her work is represented by Northlight Gallery (Kennebunkport, Maine) and Tempo Gallery (Greenville, South Carolina). Rogers is a popular instructor for watercolor workshops throughout the United States and Europe.

CONTACT INFORMATION
For information on workshops or portrait/floral commissions:
Janet Rogers
26 Sunset Blvd.
Ormond Beach, FL 32176
(904) 441-4930
E-mail: rogersart@netzero.com

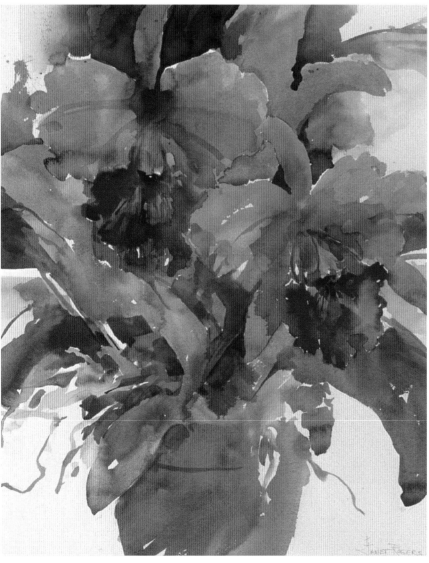

ORCHIDS
Janet Rogers
Watercolor
21" x 18" (53cm x 46cm)

Steve Rogers, A.W.S., N.W.S.

"I usually develop my paintings in a somewhat random fashion," says Steve Rogers. "This allows me to run passages together in places and leave them separate in others. Because I paint in transparent watercolor, I also leave lots of white space as I go—this keeps my options open so I can play colors against each other in the later stages of a painting."

Rogers was born in New York City, where his father was a freelance commercial artist and art director. Not sur-prisingly, Rogers grew up drawing and painting. Later, he attended Rollins College (Winter Park, Florida) and received a B.A. from Monmouth College in Illinois. Rogers is a signature member of the American Watercolor Society, the National Watercolor Society and the Florida Watercolor Society. He has received numerous awards and recognitions, and his work is included in many public and corporate collections in the United States and abroad. Rogers and his wife (Janet Rogers) maintain their home and studio in Ormond Beach, Florida. Both artists teach workshops in America and Europe.

CONTACT INFORMATION
Steve Rogers
26 Sunset Blvd.
Ormond Beach, FL 32176
(904) 441-4930 or (904) 441-0274
E-mail: rogersart@netzero.net

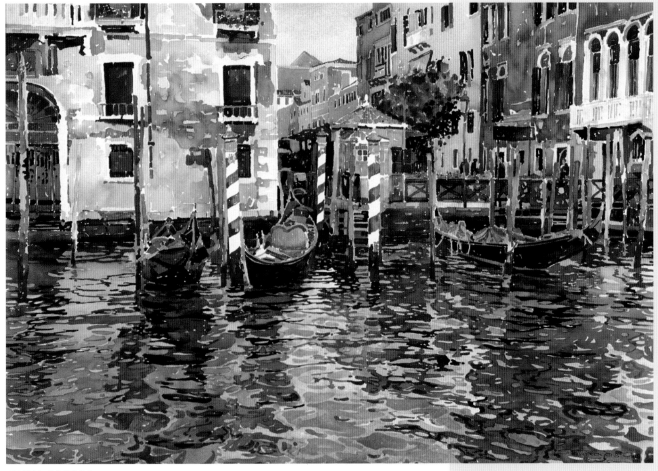

CANAL GRANDE
Steve Rogers
Watercolor
28" x 40" (71cm x 102cm)

Susanna Spann, A.W.S, N.W.S.

"I plan a full range of values, because a painting is like an orchestra—to achieve its most dramatic and satisfying potential, it needs both high-pitched piccolos (lightest values and highlights) and deep-toned bass violins (darkest darks)."

Spann was born in California, reared in Texas and Arizona and now lives in Bradenton, Florida. She received her B.F.A. and M.A. from Arizona State University before spending several years working and studying in Europe. After holding three solo exhibitions in Europe, she returned to the United States to study illustration at the Art Center College of Design in Los Angeles.

Spann's paintings have received more than 450 awards from exhibitions including both the American and National Watercolor Societies and the Florida Watercolor Society. Her paintings have been featured in *Splash I: America's Best Watercolors* and *Splash II: Breakthroughs* and an upcoming book, *Painting Crystal and Flowers in Watercolor* (North Light Books). Her work has also appeared in publications as diverse as *Arizona Highways*, *Sesame Street*, *The Lookout* and the *Illustrators Annual 20*. Spann's work is included in many corporate collections, including those of Walt Disney World, Tampa Electric Company and the City of Miami Beach. In addition to her other activities, Spann is a popular watercolor workshop instructor.

CONTACT INFORMATION
Susanna Spann, A.W.S., N.W.S.
1729 Eighth Ave. W.
Bradenton, FL 34205
(941) 747-8496
E-mail: LuvArtSpan@aol.com

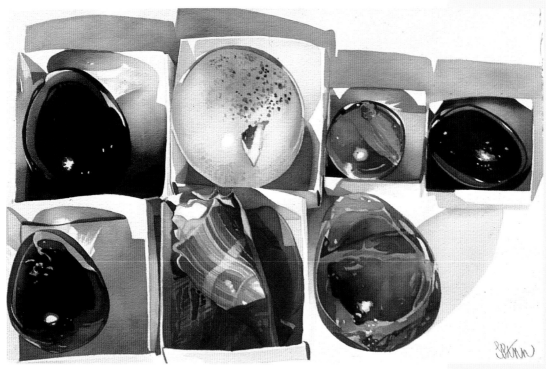

SHELL FROM SHELL ISLAND
(CRYSTALS IN CONTAINERS SERIES)
Susanna Spann
Watercolor
27" x 37" (69cm x 94cm)

Harry Thompson

"As an artist, the quest for new ways of capturing mood in my work propels my continual advancement in the realm of art. This ever-present challenge promotes my grasping and molding of new ideas, separating my work into a unique and fluid category."

Harry Thompson received a B.F.A. from Ringling School of Art (Sarasota, Florida) in 1971. After touring North America, he worked as a commercial artist He ended this career motivated by a strong desire to pursue his own artistic goals. Thompson has since supported himself as a fine artist for over twenty years and now co-owns and operates the Northlight Gallery in Kennebunkport, Maine. Thompson teaches privately and through workshops.

CONTACT INFORMATION
Harry Thompson
Mid-June to Mid-October
c/o Northlight Gallery
33 Ocean Ave.
P.O. Box 20
Kennebunkport, ME 04046
(207) 967-3320

Mid-October to Mid-June
Route 1, Box 2515
Fort White, FL 32038
(904) 454-5743
E-mail: Northlight@coastalnet.com
Web site: www.maineartists.com/
 thompson. htm

SHORT AND STOUT
Harry Thompson
Watercolor
14" x 10" (36cm x 25cm)